Modern Calligraphy

MARICAR CONCEPCION RAMOS

Inspiring | Educating | Creating | Entertaining

Brimming with creative inspiration, how-to projects, and useful information to enrich your everyday life, quarto.com is a favorite destination for those pursuing their interests and passions.

© 2022 Quarto Publishing Group USA Inc.
Artwork and text © 2022 Maricar Concepcion Ramos

First published in 2022 by Walter Foster Publishing, an imprint of The Quarto Group. 100 Cummings Center, Suite 265D, Beverly, MA 01915, USA.
T (978) 282-9590 **F** (978) 283-2742 **www.quarto.com** • **www.walterfoster.com**

Walter Foster Publishing titles are also available at discount for retail, wholesale, promotional, and bulk purchase. For details, contact the Special Sales Manager by email at specialsales@quarto.com or by mail at The Quarto Group, Attn: Special Sales Manager, 100 Cummings Center, Suite 265D, Beverly, MA 01915, USA.

ISBN: 978-0-7603-7731-4

Digital edition published in 2022
eISBN: 978-0-7603-7732-1

Printed in China
10 9 8 7 6 5 4 3 2 1

TABLE OF CONTENTS

INTRODUCTION

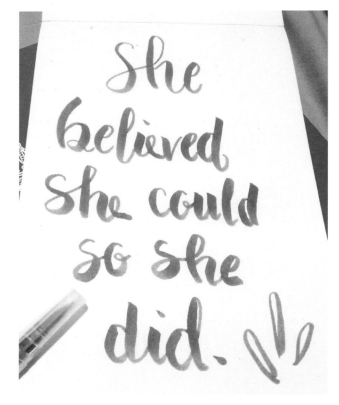

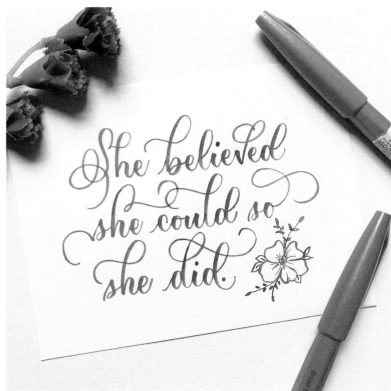

Here is one of my first lettering pieces. **And here is a more recent artwork!**

Five years ago, I struggled with stress and anxiety in my corporate job as an engineer. It felt like I had no life outside my cubicle, and I wanted to try something new and break free from my everyday routine. This kick-started my journey with brush calligraphy.

I began practicing calligraphy every night after work until I fell in love with it. Aside from the joy and calmness that calligraphy brought me, my new hobby also helped me find purpose in life.

This book is designed to help beginners get started with lettering without feeling intimidated. For those who want to take their skill set to the next level, you'll find techniques and inspiration for more advanced projects. I'll show you how simple and easy it can be by providing step-by-step explanations for creating stunning lettering pieces.

My hope is that as you learn the basics of calligraphy, you will also develop an appreciation for lettering as a form of self-expression and creativity. Brush lettering has turned my unspoken misery into victory. It led me to finding my purpose and true calling: to be creative and to be an artist. As I share my passion with the world, I want to help others experience this too.

I encourage anyone reading this book to try something new and commit to learning calligraphy because you might well discover not just your passion but also a purpose that will bring joy and fulfillment to your life.

HOW TO USE THIS BOOK

Even if you think you are not creative, this book will help you unleash the lettering artist within you.

As a self-taught lettering artist, I understand how time-consuming it is to research tools and techniques, and study how to do brush lettering properly. Learning on your own may seem complicated—but it doesn't have to be. I've designed this book in a way that makes learning a new skill fun, so you will find each lesson interesting, easy to understand, and actionable.

But I also know that along the way, you will encounter struggles and frustrations. Therefore, the first section of this book will focus on setting the right mindset. You will learn how to overcome any limiting beliefs you may have, manage the factors that can hinder your practice, and shift your thoughts when you feel like giving up.

The following sections will guide you on the recommended supplies for beginners, the fundamentals of brush calligraphy, how to find other lettering styles and techniques, and projects that will allow you to express your creativity.

You are never too old to set another goal or to dream a new dream

Treat this book as a personal project that will transform your life and not just as an added chore to your daily tasks. Whether you want to learn a skill or develop a new hobby, this book's success depends on your willingness to work hard and practice the skills that you will learn here. Don't hesitate to write on the pages, draw, and color. Make the most out of this book!

Allow yourself to experiment, try new techniques, and enjoy the process without worrying about the results or making mistakes. Let go of perfection and focus on your progress.

Now you're ready! Let's do this.

SETTING THE RIGHT MINDSET

When I started learning calligraphy back in 2017, I wasn't prepared for the frustrations and the negative feelings that I faced upon deciding to buy my first set of brush pens and take the path toward creativity. After all, I was just doing it as a hobby. But along the way, I realized that there are challenges.

The worst ENEMY of creativity is SELF-DOUBT.

— Sylvia Plath

Mindset can often be the reason that we get stuck when learning calligraphy. The right mindset will not only help set you up for success in calligraphy; it will also help you in other areas of your life. Here are some of the common limiting beliefs that may hold you back from learning calligraphy.

"I can't letter because I have bad handwriting."

Many people think that to do brush calligraphy, you must have good handwriting. If you believe that you can't do lettering because you have bad writing, the truth is that doesn't matter if it is beautiful or terrible. Anyone can learn brush lettering.

"I'm not creative."

Would you believe that I didn't see myself as a creative person when I was starting out? I was working as an engineer when I discovered calligraphy, and while I have a background in drafting, I can only draw a person with a circle and sticks. I thought that I wouldn't be able to do lettering as I've seen on social media.

The truth is, anyone can be creative if they just try. You may stumble on your road to creativity, but you will eventually reach your goals when you devote yourself to developing your creative abilities. Don't be afraid to make mistakes; they are part of the process.

"I don't have time to practice."

I had a job that was physically and mentally demanding and required me to work beyond working hours. How did I manage to practice and get better at calligraphy?

This is what I did every night after dinner and every morning before going to the office: I would spend 30 minutes to one hour learning and improving my skills. Calligraphy is my way of relaxing and de-stressing, so spending time creating something is therapeutic to me.

Do not give up on your dreams of becoming a great calligrapher just because you are not good at drawing or have lousy handwriting. Recognize your limiting beliefs and work on overcoming them.

your journey starts here

EXERCISE

To help you get started, I'd like you to complete this simple mind-setting exercise. Clarify your goals in learning brush lettering and set your inspiration and motivation when you feel like giving up.

Why do you want to learn brush lettering? (E.g., you want a new hobby; you want to do it for your wedding; you want to learn a new skill, and so on.)

What is your No. 1 limiting belief when it comes to learning calligraphy?

How do you plan to overcome this limiting belief?

TOOLS & MATERIALS

In this section, I will share some of my favorite art supplies that I've used for years now. Just a friendly warning, though: When you're buying one brush pen, it can be tempting to buy and collect more. That's normal because you're still exploring which brush pen will work for you as a beginner. However, you don't need all the materials mentioned here to make beautiful art. Start with what you have and focus on building your skills before buying more.

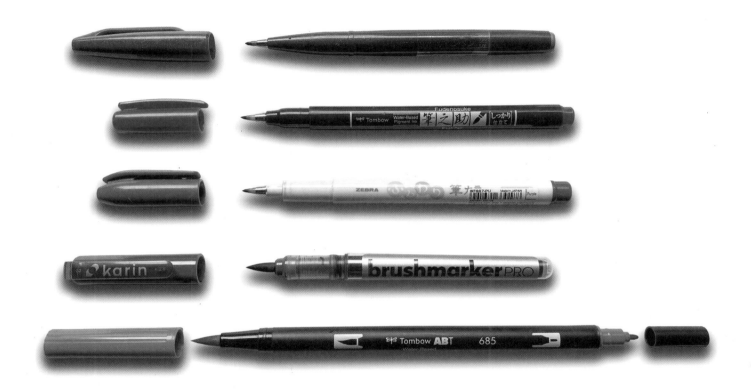

Fine-Tipped Brush Pens

Pentel® Fude Touch Brush Sign Pen: This brush pen was a total game-changer in my lettering journey. These pens are flexible and easy to control to create thin and thick strokes, and they last a long time. I've had my pens since 2017, and they are still working fine.

Tombow® Fudenosuke Brush Pen, Hard Tip: The tip is firmer than the Pentel Fude Touch, so if you're heavy-handed, this might help you control your thin strokes. You will need to apply more pressure when creating thick strokes.

Zebra® Funwari Brush Pens: The tip of this brush pen is relatively soft compared with the Tombow hard tip. It is easy to control and will give you thick downstrokes with little pressure.

Large Brush Pens

Tombow Dual Brush Pen: This brush pen has two tips. One is a brush tip that can be used for lettering, and the other is a bullet tip that can be used for regular writing or delicate lining. The brush tip is flexible and these pens are water-based, allowing you to blend colors.

Karin® Brushmarker PRO: The tip is soft and flexible and can create medium to very bold strokes. It has a nylon tip that won't fray easily, making these pens suitable to use as watercolor. Their ink is also vibrant and juicy.

TIP

Keep in mind that when you are using a large brush pen, your strokes are also larger, which means that your thin strokes might not be as light as the ones that can be achieved using fine-tipped brush pens. The contrast between thin and thick strokes should be clearly visible.

Paper

PaperOne™ Presentation 100 gsm or HP Premium32™: If you're on a budget, having a ream of one of these types of paper will be enough to practice a lot. They are smooth and thick to hold the ink of brush pens, and you can download digital worksheets online and print them on this paper.

Fabriano® Studio Watercolor Paper, 200 gsm, cold-pressed: This watercolor paper is excellent for using brush pens as watercolors. You can create an ombré lettering effect and paint florals with brush pens on this type of paper.

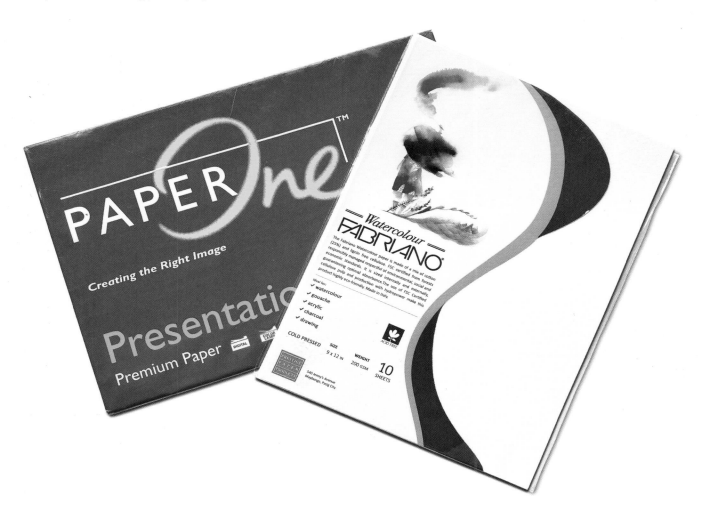

TIP

Most brush pens have delicate tips, which can easily be frayed or damaged if the proper paper is not used. I sometimes use brush pens on watercolor paper, but I recommend using smooth, high-quality paper for practice.

TIPS FOR FUN & EFFICIENT PRACTICING

Learning calligraphy can be a fun and therapeutic hobby. If you are serious about developing your lettering skills, you need to spend time practicing and make sure that you're doing it the right way.

With a busy schedule, it can be challenging to find the time to dedicate to your art. Below, I've shared tips that might help you organize your schedule and allow enough time to practice lettering.

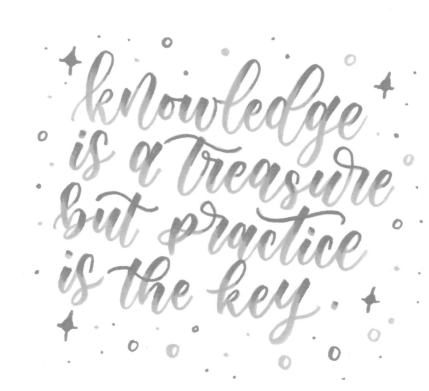

- Find a place with as few distractions as possible. This will help you to stay focused and positive while learning a new skill. Areas such as your bedroom or workspace may be suitable for this.

- Designate a time of day for practicing calligraphy. Think of this as your date with yourself. I remember spending time practicing as my form of self-care when I wanted to relax after work.

- Discuss with the people in your home that you would like to allocate that time to practice and create art. In my case, since I started practicing every night after dinner, my parents quickly got used to my schedule, and they already knew that when I went to my room, I was spending time on my art. When I got married, my husband clearly understood that I needed some time to create because I'd discussed that with him.

- Think of progress over perfection and don't compare yourself with others. It doesn't matter if you're still learning the basic strokes while others are embellishing letters. What is important is that you are taking steps to move forward. Embrace your own journey.

There is no shortcut to success, and the same principle applies when learning a new skill. Remember: the more you practice, the better you will get at it. No matter how much talent you have, it will be challenging to improve your skills over time without practice and dedication. But if you are willing to put in the time and effort, there is no limit to what level of skill that you can achieve.

THE FUNDAMENTALS OF BRUSH LETTERING

Brush lettering uses a brush pen with a flexible tip. This allows you to create thin and thick strokes by varying the pressure applied to the pen. This stroke variation is the first noticeable difference you will see when you compare calligraphy with cursive.

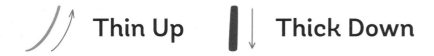

Thin Up **Thick Down**

When you move the pen upward, you create a thin upstroke. When the pen moves downward with heavy pressure, a thick downstroke is created. Remember this as you build your muscle memory: thin up, thick down.

creative

cursive writing

How you hold a brush pen makes a big difference when creating stroke variations in your lettering. I'll share some simple techniques to ensure that your brush pen works with you, not against you.

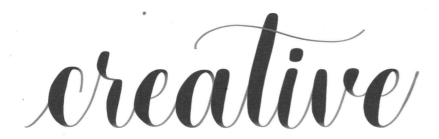

calligraphy

HOW TO HOLD A BRUSH PEN

To maximize the flexibility of the brush pen's tip, hold it at an angle. The angle of the brush pen is essential because it determines what effect you will get with your lettering.

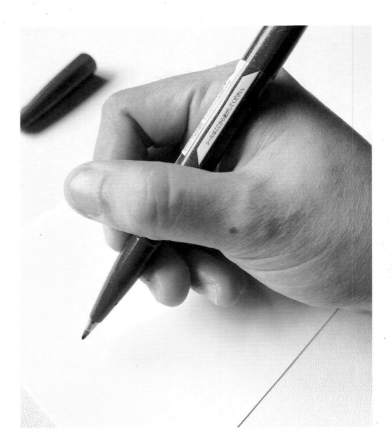

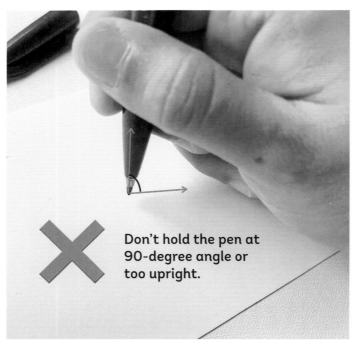

Don't hold the pen at 90-degree angle or too upright.

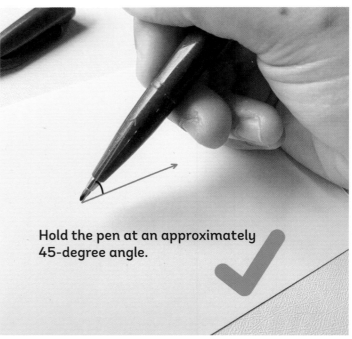

Hold the pen at an approximately 45-degree angle.

Hold your brush pen at an approximately 45-degree angle to the paper. When you hold it upright or at a 90-degree angle, you're not only damaging the tip of the brush pen, but you also won't get the full-pressure downstroke that a brush pen can create.

When the pen is at an angle, you will notice that the tip bends with heavy pressure. Don't worry; this is normal, and you won't ruin the pen if you hold it at an angle.

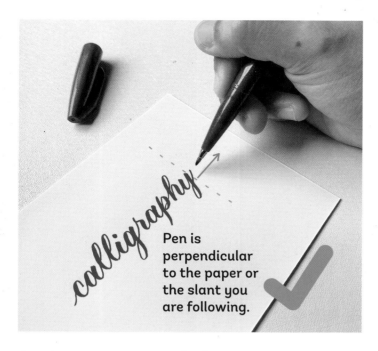

Pen is perpendicular to the paper or the slant you are following.

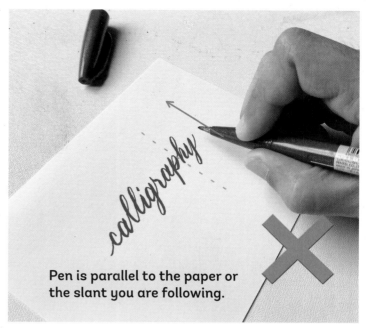

Pen is parallel to the paper or the slant you are following.

Another way to create thick strokes is to hold the pen perpendicular to the paper or the slant line that your downstroke is following.

When your pen is parallel to the paper, it is challenging to produce thick downstrokes. You want to let your pen do the work that it's designed for.

Practice these techniques and try alternating between thin and thick strokes to familiarize yourself with brush pens.

Paper Guidelines

When you're a beginner and looking to build consistency with your lettering, it's helpful to practice on paper that comes with guidelines. Remember when you first started to learn how to write in grade school? You used lined paper. The concept is the same here.

Ascender Line/Cap Height

Waistline

X *a d g*

Base Line

Descender Line

Slanted Style **Upright Style**

hi *hi*

LETTERING TERMS

X-height: the height of the main body of a lowercase letter not including ascenders and descenders (see below)

Waistline: marks the top edges of the lowercase letters

Baseline: the guideline that keeps the letters straight

Ascender line: an extension that goes above the waistline; it is found in lowercase letters like b, d, h, and k

Descender line: the bottom part of lowercase letters like g, j, p, and y; it usually goes below the baseline

Slant lines, or diagonal guidelines, keep vertical strokes parallel with one another. Usually, traditional calligraphy lies between 52 and 55 degrees. With modern calligraphy, you can follow an upright style that sits at a 90-degree angle. Sometimes there's a natural angle that you follow when you write, and you can keep it that way too.

BASIC STROKES

We've now reached the most crucial part of building a solid foundation for your calligraphy skills. When it comes to calligraphy and lettering, the basic strokes are the key to beautiful writing. It is essential to know which strokes you should be using and how they work with each letter.

For example, when written in calligraphy, the letter "m" is composed of three basic strokes—downstroke, overturn stroke, and compound curve.

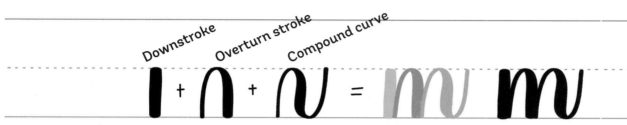

Remember that the basic strokes provide the foundation for lowercase letters in calligraphy. Do you want to make your lettering look consistent and beautiful? Make sure to practice and master the basic strokes before jumping into words.

Here are the eight basic strokes that will take your calligraphy journey to success.

To see how to draw each stroke, start with the dot, and then follow the arrow.

Upstroke (Light Pressure)	Downstroke (Heavy Pressure)		Compound Curve	Oval

Underturn	Overturn		Ascending Stem Loop	Descending Stem Loop

The Upstroke

The upstroke is a thin stroke. Also called the "entrance stroke," it starts from the baseline and ends at the waistline.

Tips for making the upstroke:

- Apply light pressure to the pen as you move upward.
- Shakiness is normal at the beginning, but with practice, it can be improved.
- Avoid flicking the pen at the end of the stroke.

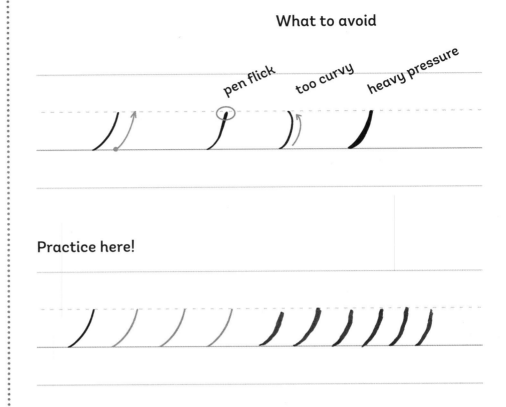

What to avoid

pen flick too curvy heavy pressure

Practice here!

The Downstroke

The downstroke is a thick stroke that starts from the waistline and ends at the baseline.

Tips for making the downstroke:

- Apply heavy pressure to the pen as you move downward.
- Thickness will vary depending on the brush pen that you use and its flexibility.
- Don't worry if you see the tip of your brush pen bend; it's designed to work this way.

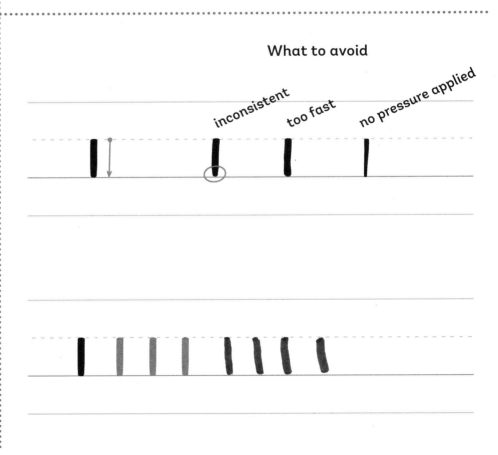

What to avoid

inconsistent too fast no pressure applied

The Underturn Stroke

The underturn is u-shaped and starts from the waistline with a thick downstroke. Before reaching the baseline, as you make the turn, slowly transition to light pressure and end with a light stroke at the waistline.

Tips for making the underturn stroke:

- Make sure the lines are parallel.
- The blue line indicates where you can make the transition.
- An early transition results in an inconsistent stroke, while a late transition results in a heavy bottom.

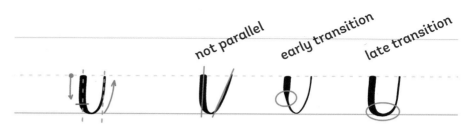

What to avoid

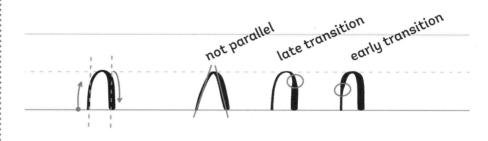

The Overturn Stroke

The overturn stroke is the opposite of the underturn. Start from the baseline with a thin upstroke, and as you reach the waistline, transition to a heavy-pressured downstroke while you make the curve to the right.

Tips for making the overturn stroke:

- Make sure the lines are parallel.
- Don't apply heavy pressure before reaching the waistline.
- Don't make the top part pointy.

What to avoid

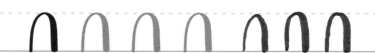

The Oval

The oval is a challenging stroke, but it will get easier with practice. Begin with a thin upstroke, and as you create the curve to the left, transition to heavy pressure to make a thick stroke. Then close the oval with a thin stroke, meeting at the starting point (the blue line).

Tips for making an oval stroke:

- Avoid an extra line inside the oval.
- Transition slowly to make a smooth oval shape.

What to avoid

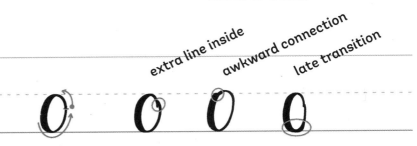

extra line inside *awkward connection* *late transition*

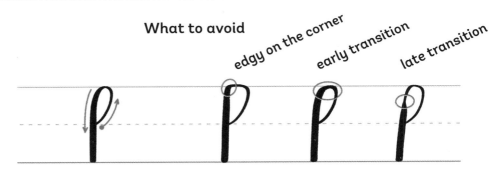

The Ascending Stem Loop

The ascending stem loop starts from the waistline with a thin upstroke. As you make a loop reaching the ascender line, transition to a full-pressure downstroke.

Tips for making the ascending stem loop:

- Avoid forming an edge at the corner of the loop.
- Make sure the transitions are done properly.

What to avoid

edgy on the corner *early transition* *late transition*

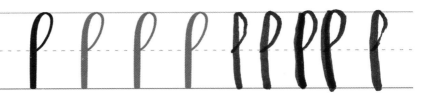

The Compound Curve

The compound curve is a combination of the overturn and underturn strokes. Start with a thin upstroke from the baseline, transition to a heavy-pressured downstroke as you make the first curve, and then end with a thin upstroke curving toward the waistline.

Tips for making the compound curve:

- Make the lines parallel.
- The distance between the two curves should be approximately equal.
- Transitions must be done slowly to create smooth strokes.

What to avoid

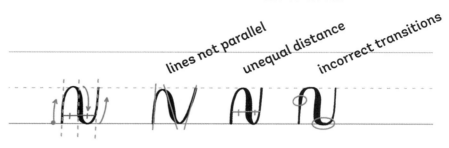

lines not parallel unequal distance incorrect transitions

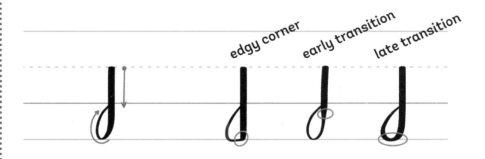

The Descending Stem Loop

The descending stem loop starts from the waistline with a heavy-pressured downstroke. Then, before reaching the descender line, transition to light pressure, create a loop, and end at the baseline.

Tips for making the descending stem loop:

- Avoid forming an edge at the corner of the loop.
- Make sure the transitions are done properly.

What to avoid

edgy corner early transition late transition

LOWERCASE LETTERS

Now that you know the basic strokes of calligraphy, it's time to write the lowercase letters. Cursive is different from calligraphy, so I've included a system that will help you practice more efficiently.

In this section, we are not going to just write letters from a to z. I always teach my students the lowercase letters divided into several groups that feature a common shape.

Before you begin writing the letters, always remember to lift your pen after each stroke.

abcdefghi

jklmnopq

rstuvwxyz

∫ + l + n = h h

TIP

You can use two different colors of brush pens to alternate with each stroke. This helps build muscle memory, so you know to lift the pen after each stroke.

Group 1: Letters with the Underturn Stroke

This group includes the letters i, t, u, w, and r.

Group 2: Letters with the Overturn & the Compound Curve

This group includes the letters m, n, v, and x.

Group 3: Letters with the Oval

This group includes the letters a, c, e, and o.

$) + O + U = a \quad a \quad a \qquad) + C = c \quad c \quad c$

$) + e = e \quad e \quad e \qquad) + O + v = o \quad o \quad o$

full-size entrance stroke → $) + O + U = a \quad a$

extra line

shorten to at least 80% → $) + O + U = a \quad a$

smooth connection ↓

TIP

When connecting letters with an oval shape, always remember to shorten the entrance stroke to avoid an extra line on the side of the oval, as shown in the illustration here.

Group 4: Letters with the Ascending Stem Loop

This group includes the letters d, h, k, and l.

Group 5: Letters with the Descending Stem Loop

This group includes the letters g, j, y, f, and q.

Group 6: The Remaining Letters

This group includes the letters b, p, s, and z.

UPPERCASE LETTERS

One of the benefits of learning calligraphy is being able to make personalized gifts that feature lettering. People love seeing their names beautifully handwritten, and you can accomplish that once you've learned how to confidently write uppercase letters.

When lettering capitals, I remember the rule of calligraphy: "thick down, thin up." By applying the correct amount of pressure to create contrast in your letters, you can come up with different ways to write uppercase letters. Explore and practice until you get the style that you want.

Note: In traditional calligraphy, the ascender line is different from the capital height. You can choose to make your uppercase letters taller than the ascender line. I make the ascender line the same as my cap height.

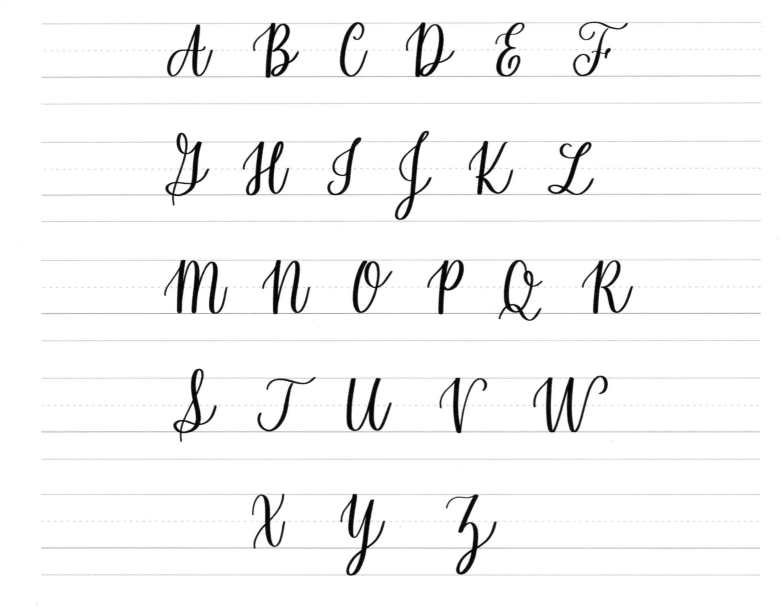

A B C D E F

G H I J K L

M N O P Q R

S T U V W

X Y Z

LETTER CONNECTIONS

Once you're comfortable with the basic strokes and lowercase letters, you can start writing words. First, though, you need to learn how to connect letters.

This section of the book highlights the three simple rules used to connect any letters in the alphabet. The truth is that you will encounter tricky letter combinations as you practice, and you may wonder how to connect those letters. Before that happens, I will spill the techniques I use every time I join letters to form words.

First Rule: Standard Connection

The standard connection means that the exit stroke of the first letter becomes the connector to the next letter. Most letters connect using this rule.

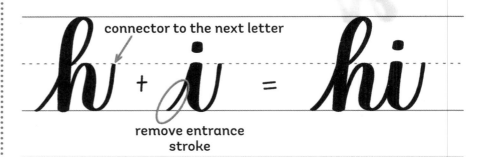

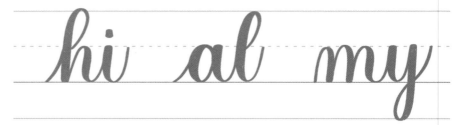

Second Rule: Oval Connection

The oval connection means that you must shorten the exit stroke of the first letter when the next shape is an oval. Remember Group 3: Letters with the Oval (page 24)? You shorten the entrance strokes to remove the extra line on the side of an oval and make a smooth connection between each stroke.

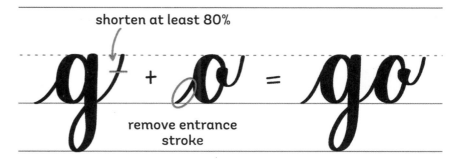

shorten at least 80%

remove entrance stroke

Third Rule: Tricky Connection

Now comes the challenging part: the tricky connection. When you encounter letters that are difficult to connect, you can either combine the shapes of the basic strokes or completely modify the style of the letter to make it easier.

combine shapes →

modify the style of the letter

FORMING WORDS

Don't rush the process, good things take time.

Now that you understand how to connect letters, it's time to write words. Words in calligraphy are just a series of basic strokes joined together. You should always remember to go slow and lift your pen after each stroke to ensure that you're forming the shapes properly and that the spacing is consistent.

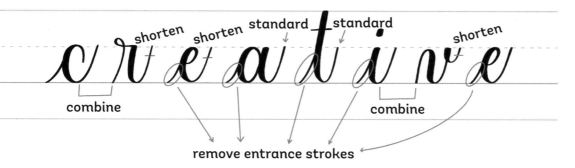

shorten shorten standard standard shorten

combine

remove entrance strokes

combine

Take a look at this example, in which I've separated the letters and indicated where and how the connections should go.

TIP

You can also do this if you find it challenging to write long words. Write the letters individually and analyze which rules may apply to connect the letters.

COLOR LEGEND

● Standard
● Shorten
● Combine

creative creative

creative

You may think that the connection of the letter i to v becomes a long stroke since you combine the underturn of the i to the compound curve of the letter v. This is another example of a tricky letter connection. If you're struggling with long combined strokes, try to completely modify the style of the letter to make it easier.

i + v = iv *i + v = iv*

The style of the letter v is
completely changed for
easier connection.

creative *creative*

creative .

over

Alexander

Alexander

Al

Alexander

For another example, let's write a name. The name Alexander features three tricky letter combinations: e to x, a to n, and e to r.

In this version, you combine the shapes of the basic strokes to connect tricky letters.

Alexander

Alexander

Alexander

In the second example, you completely change the style of the letters x, n, and r, which simplifies the connections.

What has changed? First, the compound curve of the letter x changes to a slanted underturn stroke to easily connect it to letter e. The beginning stroke of the letter n also changes from an overturn to a downstroke to avoid combining long shapes. Lastly, modify the beginning stroke of the letter r into a downstroke.

The beauty of modern calligraphy is that you have many options for writing a letter or a word, depending on your style preference. Keep exploring until you discover what works best for you, keeping in mind that the readability of the word must not be sacrificed.

Now, let's talk about spacing, one of the common struggles for beginners. Here's how you can check the proper spacing of your letters to ensure that it looks consistent throughout a word.

harmony

The red triangle indicates the spacing between the strokes and the letters, while the green oval with shading indicates the spacing between the letters.

In calligraphy, if you can fit a triangle between each stroke, that signifies proper connection and spacing. The same is true if you can fit uniform sizes of ovals between your letters. The spacing doesn't have to be completely consistent, but when you look at your words, you'll know instantly if something is odd in the spacing.

In the example below, you will notice that the spacing is not consistent.

harmony

First, let's analyze the letters h and m.

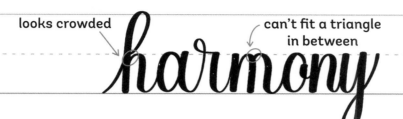

looks crowded

can't fit a triangle in between

You will see that the connection between the ascending stem loop and compound curve of the letter h looks crowded. You can't draw a triangle in that little space because the compound curve is not complete. Instead of starting from the baseline, the stroke starts below the waistline.

The letter m has the same problems. The connection of overturn stroke to the compound curve can't fit a triangle since the later stroke has not been done properly.

To fix this, remember to draw the basic strokes as they are. Form them properly and avoid any shortcuts.

Don't

The compound curve is not completed.

Do

Completed compound curve connects nicely to ascending stem loop without a heavy look.

Don't

The compound curve is not completed and attached at the top of the overturn stroke.

Do

Completed compound curve connects nicely to the side of the overturn stroke.

Next, let's analyze the spaces between letters o, n, and y.

too narrow compared with
the green ones

harmony

Here, the problem is the inconsistent spacing between the letters o and y. If you compare the ovals between the letters o, n, and y, you will notice that they are narrower than the ovals (in green) in the spaces of the first letters in the word "harmony."

Go slow as you write, and lift the pen after each stroke. When you pause and lift your pen before attaching the next shape or letter, you'll be more mindful when writing. Always think ahead about what stroke is coming next so you can adjust the spaces of the letter accordingly.

The spacing of the letters depends on how wide or narrow you prefer them to be. What matters most is that the spacing remains consistent throughout the words.

Narrow Spacing

harmony

Wide Spacing

harmony

Lastly, let's talk about consistency and what it really means to be consistent with your calligraphy.

harmony *harmony*

Consistent

all strokes are parallel
to each other

harmony

thin and thick strokes
are consistent

Inconsistent

not parallel to
other strokes

harmony

thick and thin strokes
are inconsistent

As you know by now, modern calligraphy doesn't strictly follow a traditional 55-degree angle. It's necessary, however, to follow a specific angle with all your strokes and letters—regardless of the angle.

If you prefer writing upright (a 90-degree angle), make sure that all your strokes follow that upright angle. If one of the strokes has a different slant, the viewer will notice that instead of the beauty of the word.

The contrast between thin and thick strokes also plays a role in ensuring that your lettering looks consistent. Therefore, it's essential to repeat the basic strokes and build your muscle memory before jumping into forming words.

summer winter

summer

autumn spring

FINDING YOUR OWN LETTERING STYLE

"How do I find my own lettering style?"

This is a common question that I see in the lettering community. Lots of people struggle to find their own style, but don't forget that we all have unique styles and that there are many ways to discover your own lettering preferences.

You can use books or watch tutorials to learn how to create different lettering techniques, or you can simply experiment on your own and come up with one-of-a-kind style that will eventually become your signature lettering look. Whatever works for you, follow your instincts and be confident with what you can do. Let go of any thoughts of comparing yourself with others.

Throughout my journey, I have also experienced comparing myself with other artists. If you've encountered this feeling, know that you are not alone and that it is OK to feel this way. But it's also necessary to remember that in the process of finding your own style as an artist, it's not about comparing yourself with other artists. It's about finding the unique voice that you can express in your calligraphy or lettering artworks.

As a beginner in calligraphy, it's OK if you don't have a defined style yet since you're still learning. To help you on your journey, here are a few questions to ask yourself:

1. What topics do you enjoy talking about?

If you enjoy reading poems, you can practice doing calligraphy with poem excerpts. This makes you a calligrapher who loves lettering poems!

2. What medium do you love using?

Maybe you prefer using fine-tipped brush pens like me?

3. What colors do you like to see in your art?

Some people love to use colorful pens for their designs, while others prefer to use a single color throughout the whole piece.

You can also choose the texture of your paper, do a specific lettering technique that you enjoy, or write the alphabet in different ways. Experiment until you find something you like and that speaks to you as an artist.

Once you discover what makes your art yours, you'll start to notice a pattern since you're more likely to do it repeatedly. Then it will be easier to commit to creating work in this style without getting discouraged by comparison.

Now let's look at some favorite lettering techniques to help you on your quest to find your own style.

BOUNCE LETTERING

Once you've mastered the basics and are comfortable with calligraphy, you can break the rules and explore a new style of modern calligraphy.

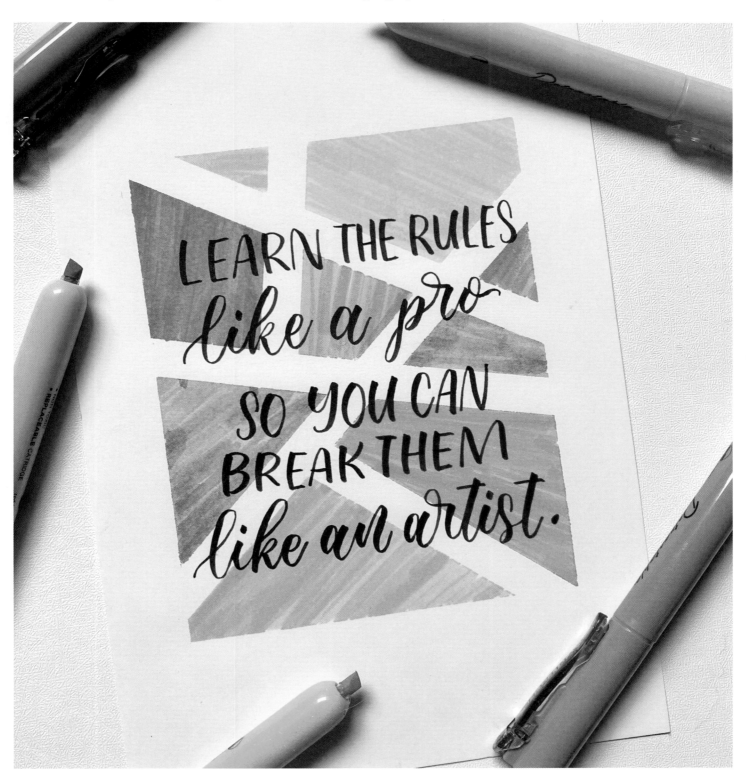

Basic Lettering

X *summer*

Bounce Lettering

X *Summer*

Bounce lettering is one of the most popular styles of modern calligraphy and can help you up your calligraphy skills. You've probably seen this style a lot on social media channels, such as when browsing for DIY lettering projects.

The difference between basic lettering and bounce lettering is that bounce lettering gives you more freedom.

The basic style of the word "summer" follows the guidelines strictly, and the letters are within the x-height. Next to it, the bounce lettering looks playful and unrestricted. You can see that the letters go beyond the x-height, which adds a more aesthetic vibe to the word.

It might seem easy to write your letters beyond the guidelines, but it can also lead to frustration when you don't get it the way you want it to be, as well as confuse readers by adding only random bounce to your lettering.

Here are my techniques for bounce calligraphy. These are not rules—just guidelines that you can follow to ensure that your words are legible.

1. Keep the ovals at the baseline or make them smaller than the usual x-height.

2. Let your underturn go below the baseline and vary the heights of letters with overturns and compound curves.

3. Emphasize loops in letters.

4. Modify the sizes of the letters from their normal x-heights.

5. Add simple flourishes.

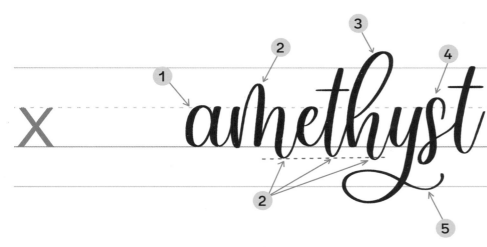

Let's discuss our sample word: amethyst.

1. The letters with ovals, a and e, remain at the baseline.

2. The overturn of the letter m goes above the waistline, while the compound curve of the letters m and h and the underturn of the letter t have different dips below the baseline.

3. The ascending stem loop of the letter h is bigger so that it exceeds the ascender line.

4. The letter s is bigger than the x-height.

5. The descending stem loop of the letter y has a simple flourish on its tail.

> ### TIP
>
> Another technique that some lettering artists use when it comes to bounce lettering is to add a curve to their downstrokes. Instead of just drawing a straight line, you can make it a little curvy.

straight downstroke	curvy downstroke	straight downstroke	curvy downstroke
m	m	h	h

It's not necessary to add bounce to every letter in a word. Just follow the simple guidelines that I've shared and look for balance in the word.

Lowercase Bounce Letters

a b c d e f
g h i j k l
m n o p q r
s t u v w x
y z

a b c d e f

g h i j k l

m n o p q r

s t u v w x

y z

summer winter autumn spring

Uppercase Bounce Letters

A B C D E

F G H I J

K L M N O

P Q R S T U

V W X Y Z

A B C D E

F G H I J

K L M N O

P Q R S T U

V W X Y Z

EXTENDED LETTERING

With the extended lettering style, all the exit strokes of the letters are extended, making the spaces between the letters wider than you see with basic and bouncy styles. You can do this style in an upright or a slanted version, but I prefer doing it on a slant since it feels more elegant and dramatic.

The key to extended lettering is to ensure that the stretched spaces will look approximately equal and consistent. You don't have to perfect the expanded spacing between each letter, but don't vary it too much.

Upright Extended Style

enlight

Slanted Extended Style

enlight

Your lettering style will look uneven if one of the spaces is narrower or wider than the expanded space.

consistent expanded spaces

enlight

narrow space wide space

As with basic brush lettering, extended lettering follows the guidelines, so the letters sit within the x-height. But you can also try mixing extended and bouncy lettering! Try it and see if you love the result.

a b c d e

f g h i j

k l m n o

p q r s t u

v w x y z

a b c d e

f g h i j

k l m n o

p q r s t u

v w x y z

summer

winter

autumn

spring

WHIMSICAL LETTERING

Whimsical lettering can look different for every artist. Here I'm sharing my interpretation of whimsical lettering. Remember that with modern calligraphy, you can come up with your own style, and I'm simply providing some inspiration to use as a starting point.

This style of lettering is simple and just requires curves in the words. Here's how I practice whimsical lettering.

1. Add curves to the entrance and exit strokes of a word.

2. If the word has an underturn stroke, adjust its form to go below the baseline while still adding a curve to it.

3. Flourish the crossbar of the letter t with a curve.

The letters are within the x-height, but you can try modifying the letter forms to bounce style, but with added curves.

basket

flourished cross bar with curve

curvy exit stroke

curvy entrance stroke

underturn extends below the baseline

a b c d e f

g h i j k l

m n o p q r

s t u v w x

y z

a b c d e f

g h i j k l

m n o p q r

s t u v w x

y z

summer *winter*

autumn *spring*

COMBINING BRUSH SCRIPT WITH SERIF AND SANS SERIF

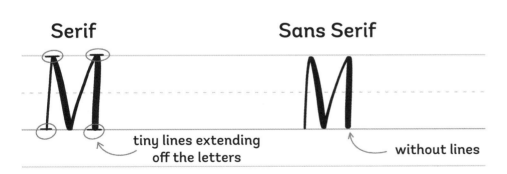

Serif

Sans Serif

tiny lines extending off the letters

without lines

You may have seen lettering compositions that feature mixed lettering styles. Combining brush script with block letters is a popular way to do this.

Before we jump into writing, let's look at the difference between serif and sans serif fonts.

Serif letters have tiny lines extending off them, and sans serif letters don't have those lines. If you get confused, remember that *sans* is a French word that means "without," so sans serif letters are letters without lines.

Serif Letters

A B C D E F

G H I J K L

M N O P Q

R S T U V

W X Y Z

A B C D E F

G H I J K L

M N O P Q

R S T U V

W X Y Z

Sans Serif Letters

A B C D E F

G H I J K L

M N O P Q R

S T U V W

X Y Z

A B C D E F

G H I J K L

M N O P Q R

S T U V W

X Y Z

Learn to REST not to QUIT.

Now, let's see how we can combine these with brush script using the example to the left.

I've written the words "rest" and "quit" using sans serif to emphasize these words, while the remaining words use the basic lettering style.

Learn to REST not to QUIT.

LIFE
is but a
DREAM.

Now look at the second example, which combines extended lettering with serif. I love how the flowy look of extended lettering complements the meaning of the quote.

 PRACTICE HERE

LIFE
is but a
DREAM.

FLOURISHES & EMBELLISHMENTS

One of the most exciting ways to advance your skills as a calligrapher is by learning how to flourish.

Flourishing empowers your words through embellishments that make them jump off the page with aesthetic, graceful expression and excitement. It enhances the beauty and meaning of words or phrases by adding elegance that includes shapes like curves, spirals, and leaves.

This section explores the basics of flourishing and looks at the different ways that you can apply it to your calligraphy. I've also provided some guidance on how you can start designing flourishes yourself to add a little more energy and creativity to your writing.

Always try one more time before you quit all your hopes.

There are many ways to add flourish to modern calligraphy. The easiest and most popular approach involves adding basic loops and swirls at either the start or the end of a word. A more complicated method takes additional time to design and involves more loops that may cross over other curves.

Flourishing Fundamentals

The basic shape of a flourish is an oval. Therefore, if you want the flourishing of your calligraphy to look elegant and graceful, I recommend that you practice various oval shapes. Flourishes look more natural if you allow them to be large and flowy.

If you look at the basic calligraphy form of the sample word "complicated," you'll see that all the letters sit on the baseline and the ascenders and descenders follow the guidelines.

easy

complicated

TIP

Using a pencil to practice drawing oval shapes will help familiarize yourself with it more effectively. Ignore the thin and thick strokes at first—just focus on the shape and the movement of your hand.

Now, let's look at the flourished form of the same word. The strokes drawn in orange are the flourishes. You will notice that these extended strokes go beyond the baseline, ascender, and descender lines.

Basic Calligraphy

complicated

Flourishes

complicated

Basic form of the calligraphy sitting on the baseline

Vertical Ovals

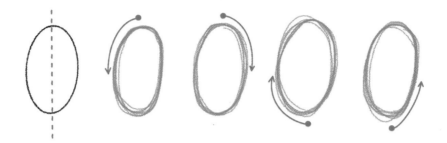

Horizontal Ovals

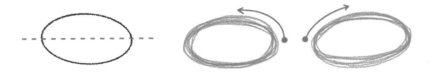

Spiral Ovals

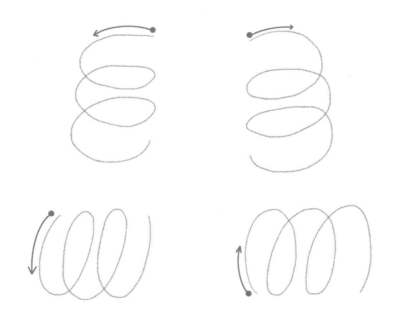

Flourishes don't follow guidelines, so you have more freedom when adding embellishments to your calligraphy. Drawing larger flourishes will make them appear more intentional, as opposed to looking like a distracting extra curve on the letter.

For beginners, making big strokes can be challenging. With calligraphy, you use your fingers and wrist to move the pen around and draw letters. As you learn to flourish, practice large, flowy strokes that require forearm movement.

The exercises here will help you practice forearm movement and ensure that your flourishes look smooth and steady.

TIP

Make sure your forearm is resting on the table as you flourish to keep your movements steady.

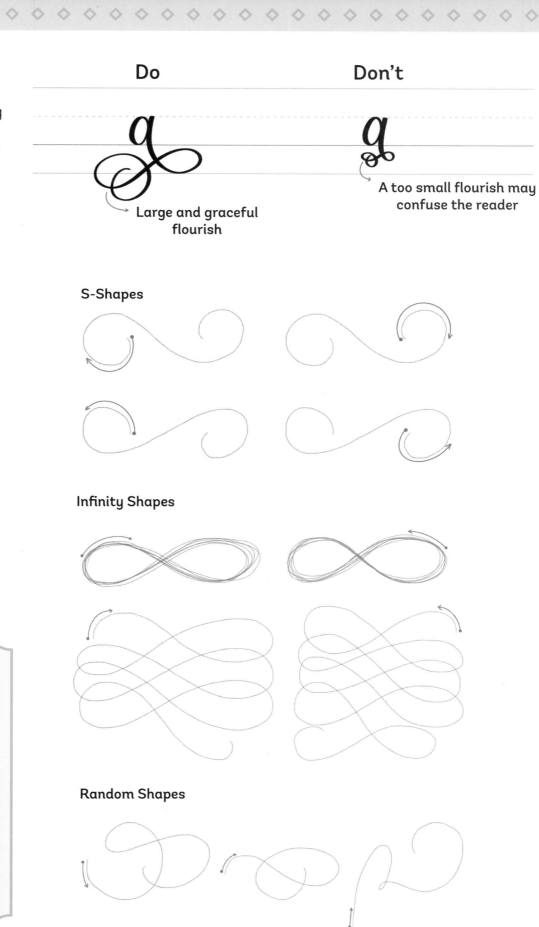

Do

Large and graceful flourish

Don't

A too small flourish may confuse the reader

S-Shapes

Infinity Shapes

Random Shapes

When creating complex flourishes, you may encounter overlapping strokes. Try to aim for a perpendicular angle when you cross two lines. That will ensure that you have enough white spaces between the ovals of the flourish. To avoid a heavy spot that can be distracting to the eye, do not cross two thick lines. You can cross a thin and thick line or two thin lines.

Do	Don't
Cross lines perpendicularly.	**Make the angle too wide.**

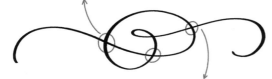
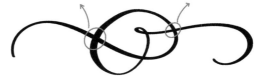

Cross thin and thick lines.

Cross two thick lines.

Cross two thin lines.

Have proper spacing.

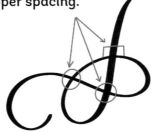

Create a heavy, distracting spot.

TIP

When drawing flourishes, you may choose to follow the "thin up, thick down" rule of calligraphy. However, if you want elegant flourishes that are simply thin strokes extending from the basic form of the letters, that's OK too!

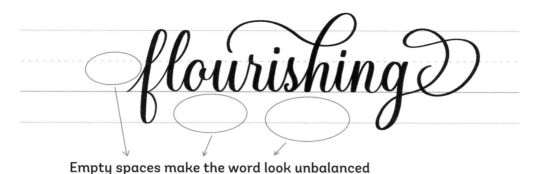

Empty spaces make the word look unbalanced

Notice the overall balance of the flourishes in a word.

If you add a flourish on the right side of the word but leave the left side empty, the whole design will look uneven. This also happens when you fill the spaces at the top of the word or phrase with flourishes while forgetting about the bottom.

Balanced Flourishes

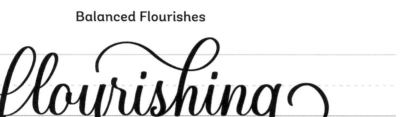

In this example of unbalanced flourishes, the embellishments go only to the top and end of the word. The flourishes are on the letters h and g. The beginning and bottom parts of the word are empty.

In the example of balanced flourishes, I've added an entry flourish to the letter f while changing the exit flourish of the letter g to balance it with the size of the entrance flourish. To avoid a top-heavy look with only the letter h having an embellishment, I've added flourishes to the letter u and the descending stem loop of the letter g.

Keep the curves as curved as possible. A graceful flourish depends on a smooth curve. Make sure that the ends of your flourishes are curvy, not straight, or they may look tight and restricted.

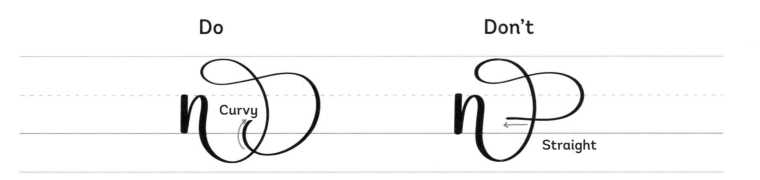

Do Don't

Curvy Straight

WHERE TO PLACE FLOURISHES

Now, you may be wondering where to add flourishes in a word. It's time to reveal my secrets!

Without planning, flourishing can be tricky and messy. Here are the usual places to add flourishes:

• The beginning of a word (entry stroke flourishes)
• The end of a word (exit stroke flourishes)
• The ascender loops (top flourishes)
• The descender loops (bottom flourishes)
• Middle of the word (underline flourishes)
• Crossbars

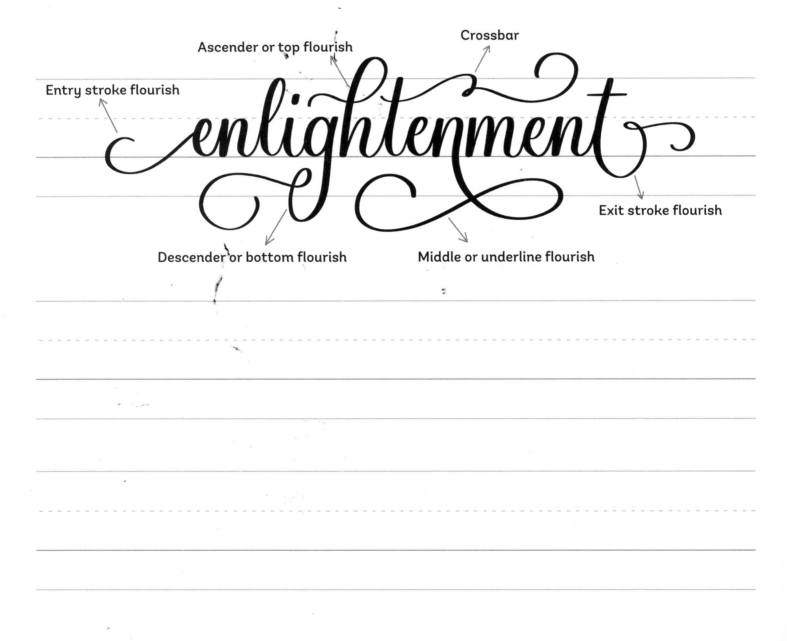

To help you practice flourishing, I've grouped the lowercase letters according to the best spots you can place them in a word. Keep in mind that there are many ways to design a flourish. By experimenting with ovals, you can come up with unique styles of your own.

Ascender loops or flourishes that can be placed at the top of the word (b, d, h, k, l)

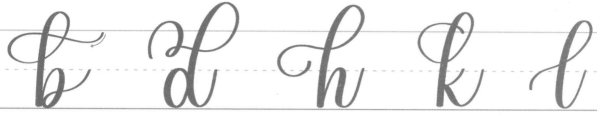

Descender loops or flourishes that can be placed at the bottom of the word (g, j, p, q, y)

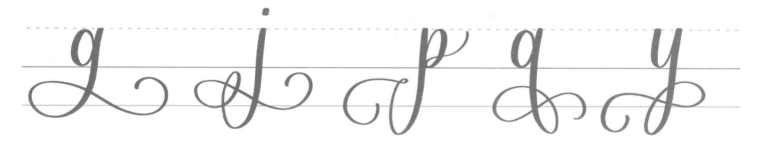

End-of-the-word flourishes that can be placed on underturns and overturns (a, m, n, r, u, w)

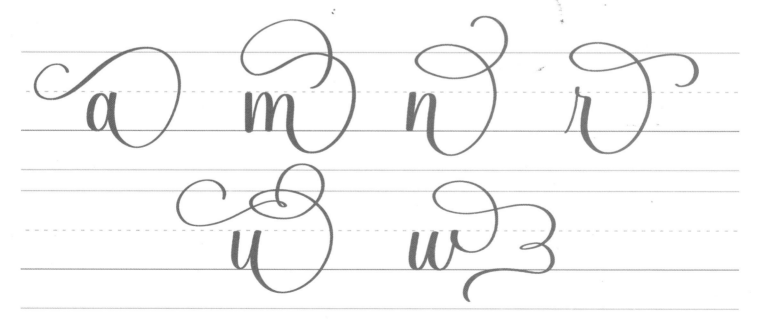

Middle-of-the-word flourishes that can be placed on underturns or overturns (a, m, n, r, u)

Entry stroke flourishes, placed at the beginning of the word

Exit stroke flourishes, placed at the end of the word

Crossbar

Some letters are more challenging to flourish than the ones in the examples, but that doesn't mean you can't add flourishes to them. Look at the word and consider whether there's a good spot for an embellishment.

HOW TO PLAN FLOURISHES

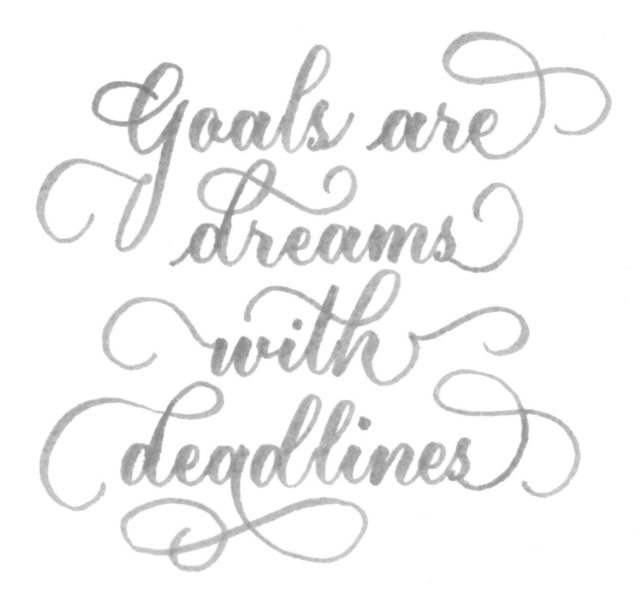

As mentioned earlier, there are different ways to flourish a letter. That's good news! It means there's no right or wrong way to flourish. A single word can have more than one style of flourish. As long as the legibility of the word is not compromised, you can choose to flourish using simple or complex designs.

In this section, I'm sharing my method for planning flourishes. I find that using a pencil is best when it comes to drafting designs because you can easily erase it if something doesn't look good.

1 Write a word using your basic calligraphy style. Don't forget to use guidelines to ensure consistent letters.

2 Analyze the letters in the word and identify areas where you could add flourishes.

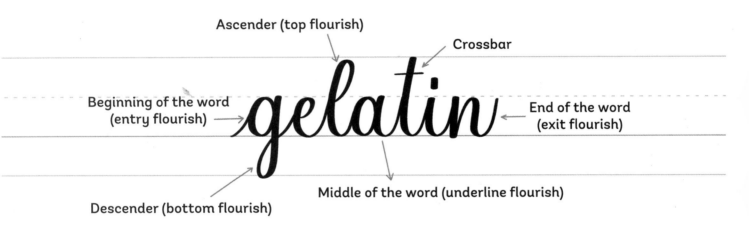

3 Using a pencil, outline the design of your flourishes by attaching them to the letters. Look at both sides of the word and the top and bottom parts to balance the embellishments. Don't be afraid to erase if you feel that some flourishes don't look good. Experiment with different flourishes until you're satisfied with the design.

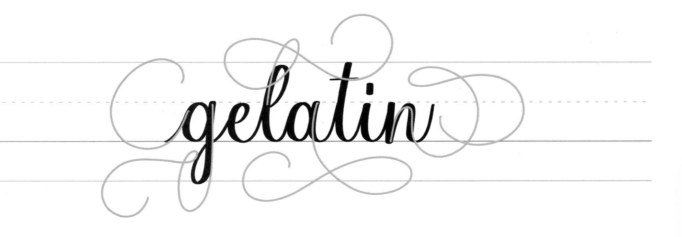

4 Grab your brush pen and start inking the word.

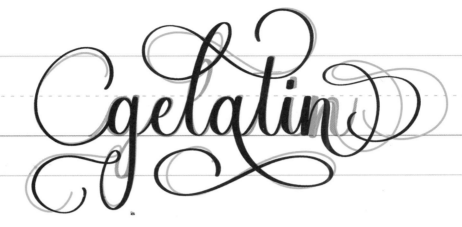

5 To avoid smudging, wait for the ink to dry before you erase the pencil lines.

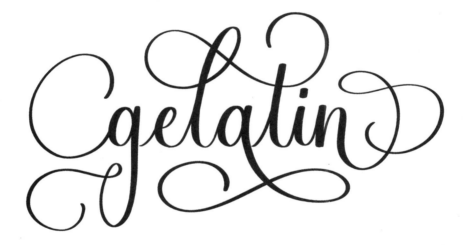

In this example, there are six flourishes—but that doesn't mean you must do it this way. You could also choose to simplify your design and flourish only some of the letters while still maintaining balance in the word.

You might want to come up with different designs, as seen in the example on the right.

It doesn't matter how simple or complex your design is if the word is readable. Flourishing is not just a way to embellish your work through creative enhancement; it's also an opportunity to demonstrate your skills—so have fun with it!

TURNING LETTERING INTO ARTWORK

Want to know an easy way to turn your calligraphy into a piece of artwork? Frame it! Because of its beauty and elegance, calligraphed quotes are often used as home and office décor. You might want to make art from quotes or phrases that inspire you. Maybe you'd like to hang them on the wall or place them next to your desk to motivate yourself as you work. There are many styles of modern calligraphy to choose from to suit the style and theme of any room.

If you feel like it's challenging to create an original design, don't worry! This section walks you through my method for creating frame-worthy calligraphy compositions.

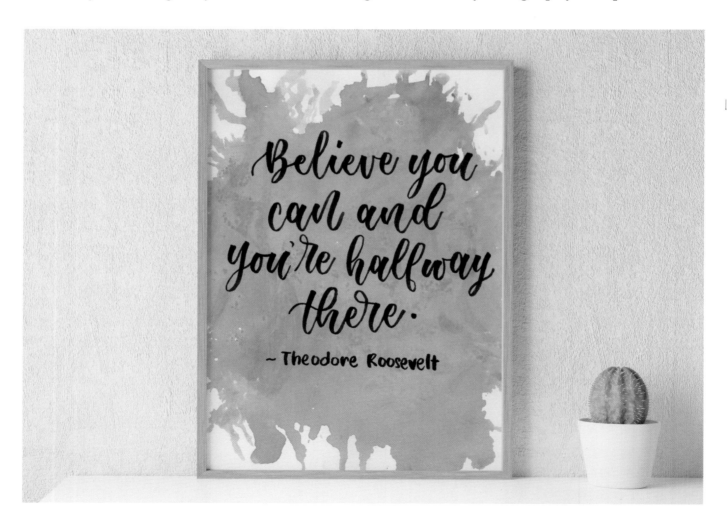

Composition Tips & Tricks

When planning your calligraphy design, the most important factors are that it should look pleasing and be easy to read. In calligraphy, composition is the sum of all the elements combined to make a work of art convey its intended meaning or message.

Here are some common factors to consider when designing a composition for your calligraphy piece. These can be applied to quotes on the wall, invitations, and other projects. An added benefit is that if you still find yourself lost in determining your calligraphy style, these will also help you discover it! Let's dive in.

Theme
Do you want your design to look elegant but simple? Plain calligraphy art is perfect for a minimalist house. Perhaps you want the vibe to be playful and fun? You can add decorations to your lettering for a modern look.

Color Scheme
If your theme is minimalist, a plain black color may work best. You can also choose to make your piece super colorful. There are many color palette inspirations online, such as pastel, vintage, muted, or bright. Set the color depending on the mood you want the readers to get from your art.

Winners
-NEVER-
Quit

escape
the
ordinary

conquer
from
within

Size of the Brush Pen or Marker

It may seem like a tiny detail, but the size of the brush pen makes a big difference in the final output. Using a large-tip brush pen can make a word look bold and edgy, while a fine-tip brush pen can create a soft and whimsical look.

Shape

The most common design shape for a quote is rectangular, but you can try to fit your words into a circle, a square, or any other structure that you can think of. You can also put words in a curving or diagonal direction.

Spacing

The spacing between each line of the quote or paragraph also contributes to the finished look of your artwork. Some designs might look best with all the words squeezed altogether, while others take as much space as they can.

Emotion

Words can express feelings if you choose the right kind of calligraphy for your writing. Choose bouncy or extended lettering if you want the design to look lively, or add flourishing to impress your friends and family.

IMPORTANT NOTE

When writing quotes or poems in calligraphy, make sure to credit the author or person who said it by writing the name(s) below the quote.

CREATING A BEAUTIFUL LAYOUT

Now that you're familiar with the different factors that contribute to a composition, let's put them into action by learning how to create your work of art in calligraphy. This step-by-step process shows how to do it without getting overwhelmed.

Let's use this quote as an example: "Your patience is power."

Step 1: Write
Write the whole quote so you won't miss any words. Don't worry about designing it yet; just write it in your usual handwriting.

Your patience is power.

Step 2: Emphasize
Not all words in a sentence are equally necessary. Choose the words that you want to emphasize; they will be the main focal words.

In this example, "patience" and "power" are the main words in the quote, so let's underline them or put them in a box.

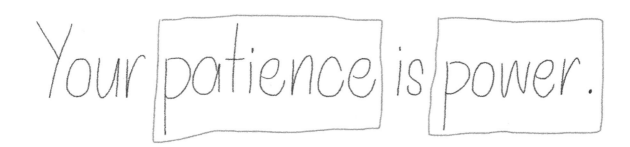

Your patience is power.

Step 3: Layout

Applying some of the factors in composition (page 75), create thumbnails or smaller versions of the design you wish to make. You can start by drawing shapes to see which will best suit your quote.

Shape 1

Shape 2

Shape 3

Using your handwriting, fill the shapes with the words in the quote. Try different layouts by dividing the words or phrases in various ways.

1

Your
patience
is
power.

2

Your
patience
is power.

3

Your patience
is power.

Step 4: Stylize

Once you've drafted some layouts using your handwriting, it's time to make different designs. Decide whether you want to keep the look simple or playful. Pick a lettering style or mix brush script with serif letters. Again, try different versions and have fun with the process.

1

Your patience is power.

YOUR patience is power.

2

Your patience is power.

your patience is power

3

Your patience is power.

Your patience is power.

Step 5: Embellish

Add elements or embellishments if you need to fill any awkward negative spaces. Try adding leaves, floral elements, stars, or dots around the quote.

1

Your
patience
is
power.

YOUR
patience
~IS~
power.

2

Your
patience
is power

your
patience
is power

3

Your patience
is power.

Your patience
is power.

Step 6: Trace

Look at your calligraphy compositions and choose the one you like the most. Then start creating it in the actual size that you want your artwork to be. Using a guideline helps maintain the consistency of your letters. You can trace the pencil markings or use a light pad to trace the design.

If you need to adjust the spacing or letters or change anything in your composition, you can do this while tracing the initial design. If you're satisfied with the design of your composition and have nothing more to add, it's time to ink it with your brush pens.

1

2

3

Step 7: Finish

Wait for the ink to dry before erasing any pencil markings on your artwork.

Congratulations! You've just finished your first calligraphy masterpiece! Remember that composition is used in calligraphy to understand how the words in a phrase or quote come together to make an artwork. Don't worry if it's not perfect on your first try. Practice and keep trying. Most importantly, enjoy the process!

1

YOUR
patience
~IS~
power.

2

your
patience
is power.

3

Your patience
is power.

LETTERING PROJECTS

Some people think of calligraphy as traditional and old-fashioned—but it doesn't have to be! Over the years, calligraphy has evolved, and there are now many techniques and styles that you can apply in different ways to create art and express your creativity. While traditional calligraphy is often considered more sophisticated, modern calligraphy is whimsical and fun.

One of the most exciting parts of learning calligraphy is applying your skills to create artworks and projects. This section highlights some interesting modern calligraphy techniques. These techniques are simple to learn and follow, and you can use them to make various artworks of your own.

Let's create something today!

Creativity is inventing, experimenting, growing, taking risks, breaking rules, making mistakes, and having fun.

MARY LOU COOK

BRUSH PEN LETTERING

One of the most popular techniques used by modern calligraphers is blending. Blending allows you to mix colors and is done using water-based brush pens or markers. If you're not sure whether your brush pen is water-based, check its barrel or packaging, where it usually is indicated.

This project teaches you how to blend two colors. If you want to combine more than two colors, you can apply the same technique that you will learn here.

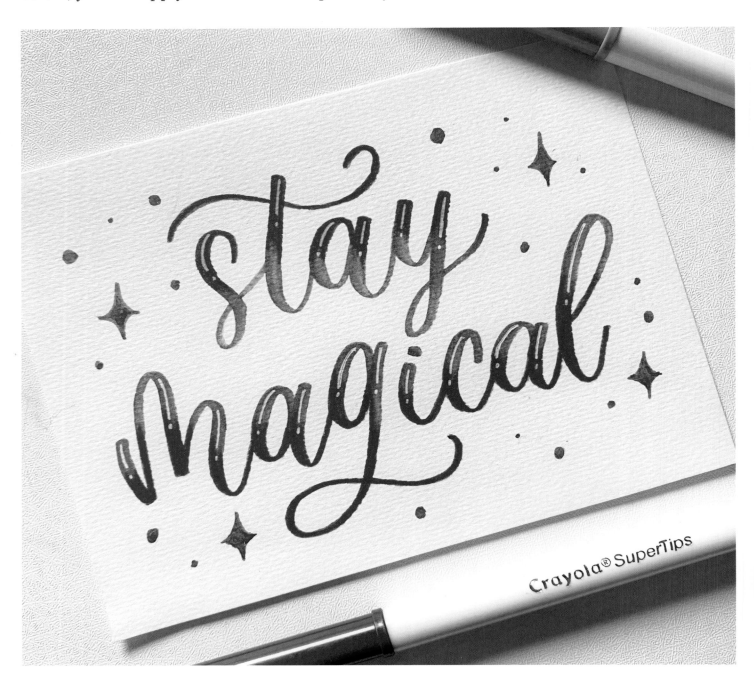

TOOLS & MATERIALS

First, prepare your materials. When choosing the colors to blend, use ones that complement each other or are in the same color family. Make sure you have one light and one darker color.

When blending, I recommend using watercolor paper to achieve the best results. Artists sometimes struggle to make blending appear seamless, and one cause is that their paper isn't thick enough.

There are many ways to create unique color blends. You can use:

• A colorless blender, as in this project. I'm using the Tombow Colorless Blender.
• A small, wet paintbrush
• The lighter color to blend with the darker one
• Optional: a white pen to add dimension to your lettering. I'm using a Sakura® Gelly Roll® Classic™ White.

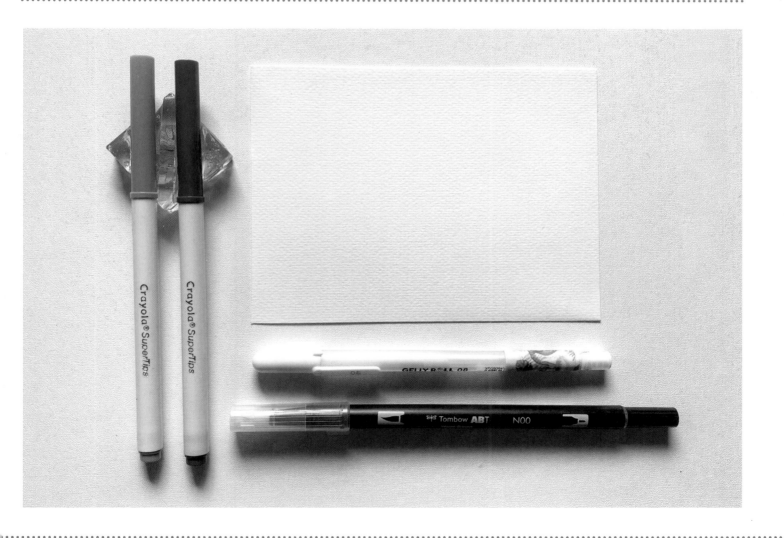

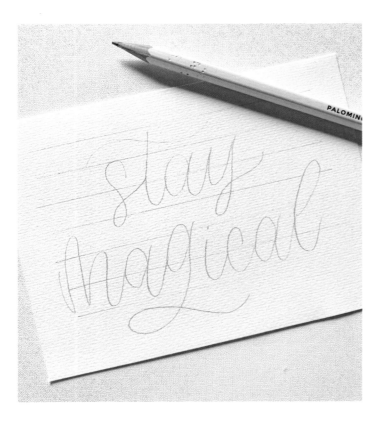

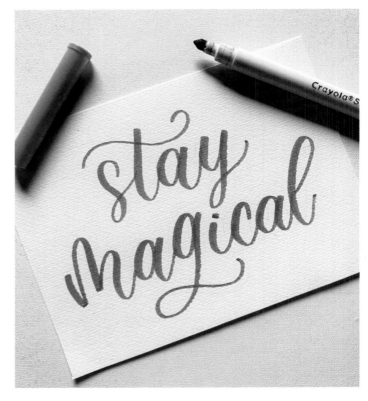

Step 1

Draft the quote with a pencil to ensure proper spacing and consistency.

Step 2

Add ink to the quote in any style you like using the lighter color.

Step 3

When blending with brush pens, you can decide whether you want the top or bottom part of the word to appear darker. I'm showing you both here.

Start by applying the dark color at the top of the word "stay." Use short and feathery brushstrokes with the tip of your pen to achieve a smoother color transition. Use uneven, jagged strokes rather than making the edge of the darker color look perfect or square.

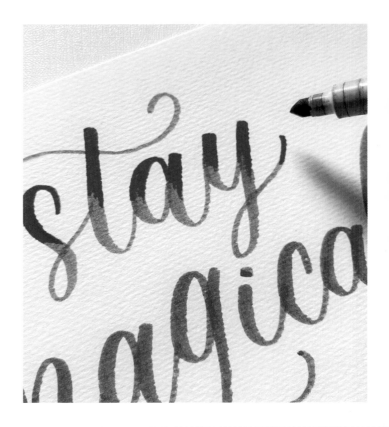

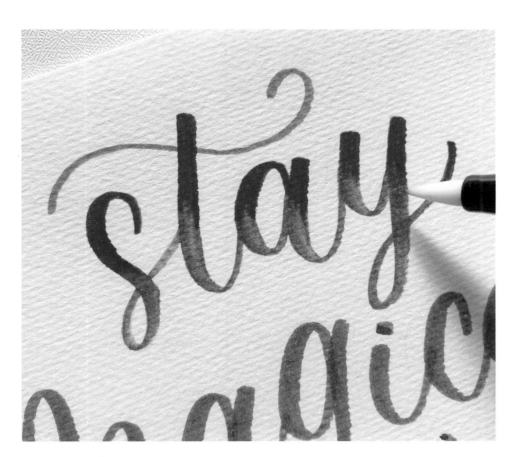

Step 4

Using colorless blender or another blending material, blend the colors by dragging the darker color down to the bottom of the letter. Don't start dragging from the top of the letter; go from the spot where the colors meet.

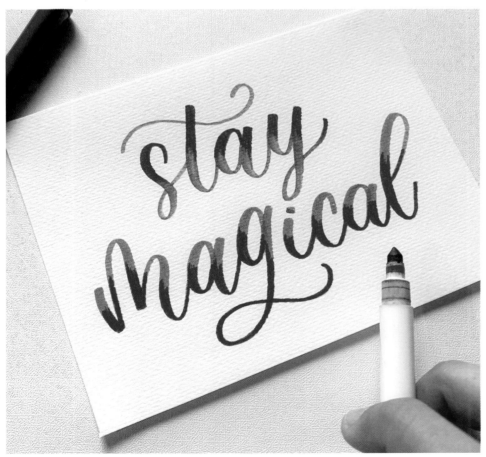

Step 5

Repeat steps 3 and 4 for the word "magical," but this time, try to add the darker color at the bottom of the word.

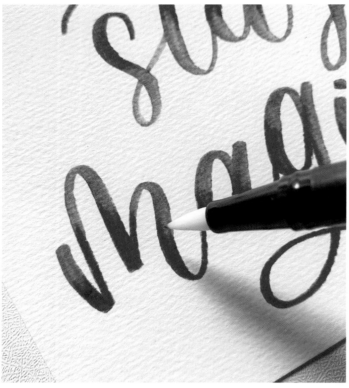

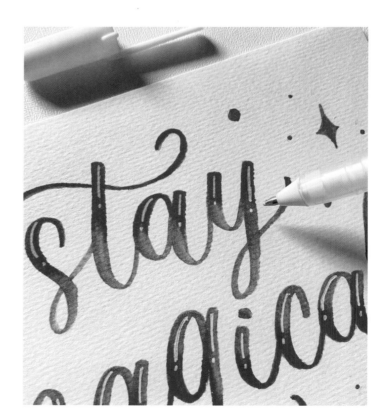

Step 6

Drag the darker color toward the top of the word and blend smoothly.

Step 7

Add stars and dots around the quote to embellish the design.

Step 8

This step is optional, but if you have a white pen, draw a thin line and a dot in the thick strokes of each letter to add depth to your lettering.

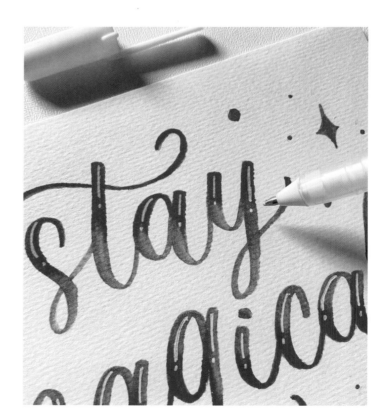

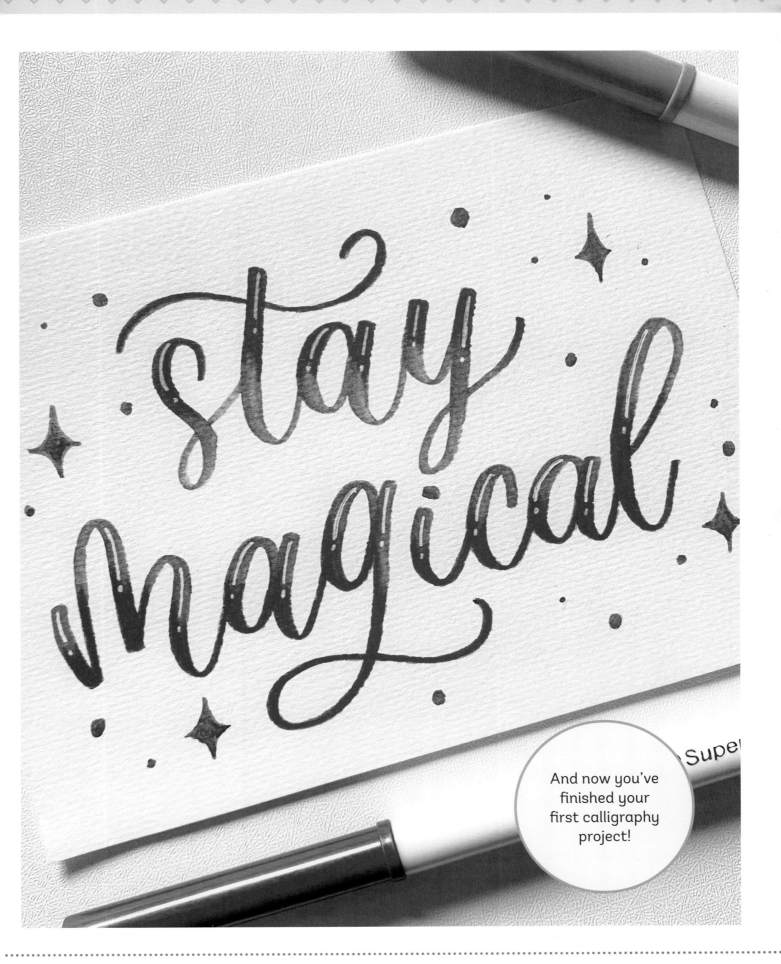

And now you've finished your first calligraphy project!

PAINTING FEATHERS WITH BRUSH PENS

This project showcases a simple feather wreath made with brush pens.

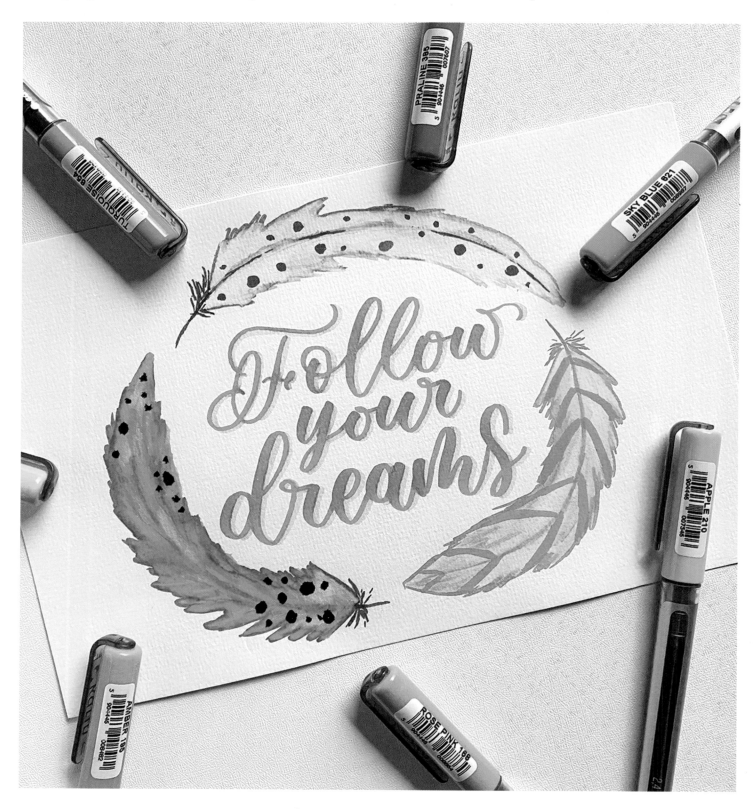

TOOLS & MATERIALS

- I've used Karin Brushmarkers PRO, but you can use any water-based markers. Choose any colors you love!

- You will also need a round paintbrush to paint the feathers. Mine is a size 5. Don't forget to have a jar of clean water to dip your paintbrush.

- Watercolor paper of at least 200 gsm is best for this project.

Step 1

Draft the composition of your quote using a pencil, and add three curves around it. These curves will act as a guide for the stems, or rachises, of the feathers.

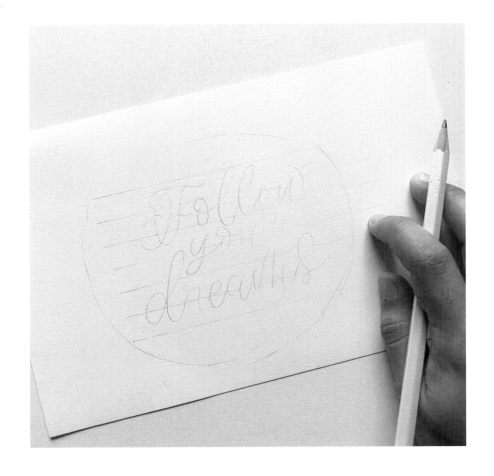

Step 2

Lightly erase the pencil marks, and then trace the quote using a brush pen.

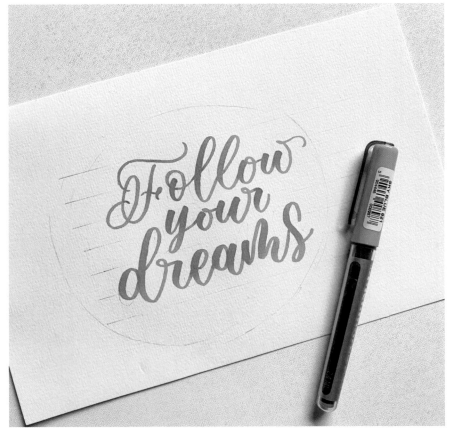

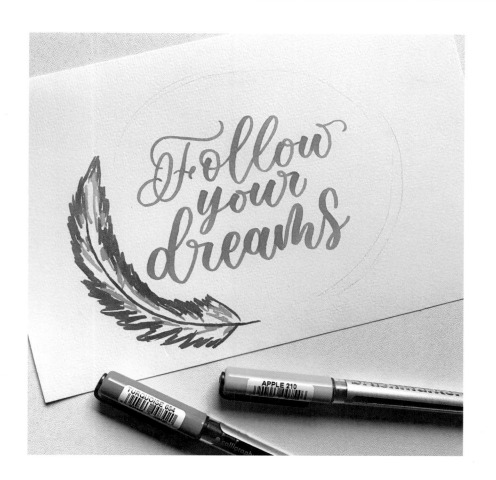

Step 3
Draw the outline of a feather by creating imperfect spiky strokes that form the shape. Add a complementary color in random spots.

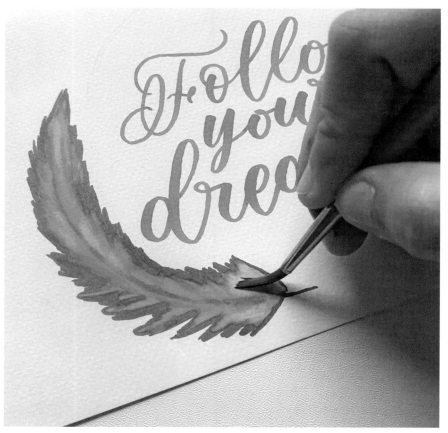

Step 4
Dip the paintbrush into water and start blending the colors while filling the remaining white spaces.

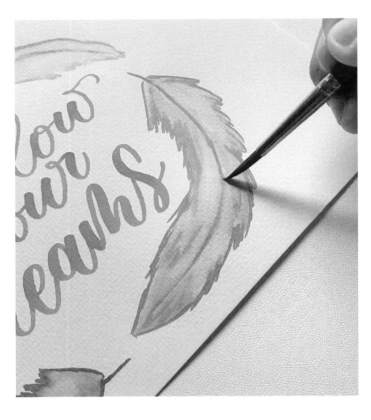

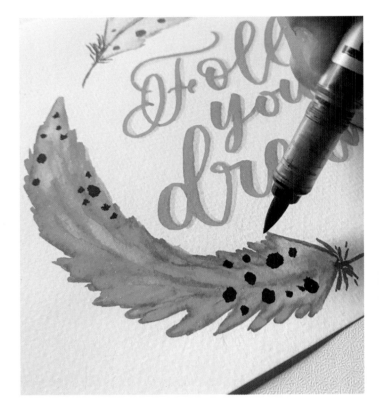

Step 5
Repeat steps 3 and 4, using different colors for the other two feathers.

Step 6
Let the feathers dry, and then add finishing touches like dots and lines inside the feathers to make the piece look more dynamic.

Step 7
Since I've used a light blue color for my calligraphy, I've added shadows with a cool gray color that adds depth and "pop" to the quote. (See pages 98-99 for tips on adding shadows.)

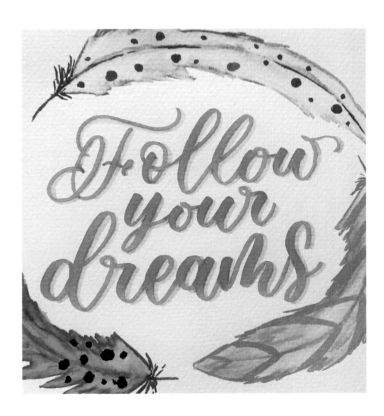

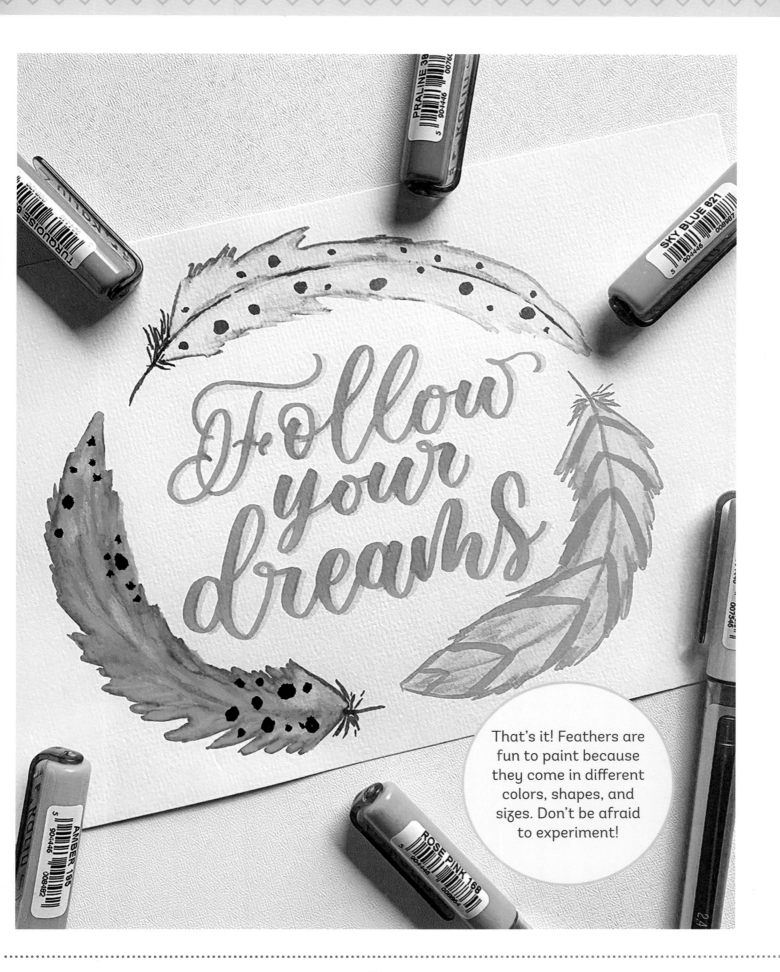

That's it! Feathers are fun to paint because they come in different colors, shapes, and sizes. Don't be afraid to experiment!

SHADOWING TECHNIQUES

Shadowing is a technique used by many modern calligraphy artists to give a 3D effect to their letters. It makes the words pop with dimension and enhances the overall look of your lettering.

Shadows are a dark area, a figure, or an image cast on the ground or another surface by a body intercepting light. In lettering, the words written in calligraphy are the ones blocking the light. When determining where to add shadows, you must first decide where the light is coming from. Remember that the light source is always opposite the shadows. So, if your light source is from the right, the shadows appear on the left side, and vice versa.

It doesn't matter where you place the shadows. I personally prefer putting them on the right side, but the important thing is to stay consistent throughout all the words in your piece.

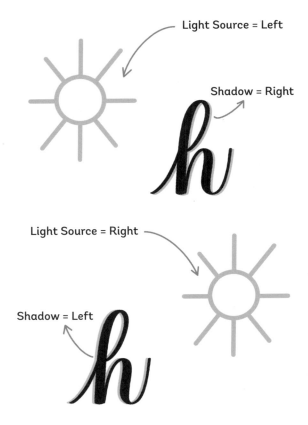

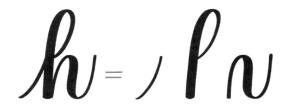

If you're still confused about how to add shadows to letters, let's break down the sample letter h into a series of basic strokes.

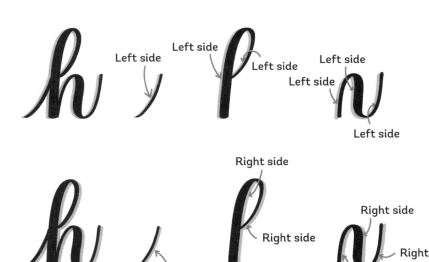

a b c d e

f g h i j

k l m m n o

p q r s t

u v w x y z

Here's a lowercase alphabet chart
with shadows on the right side for
your easy reference.

FLORAL CALLIGRAPHY BOOKMARK

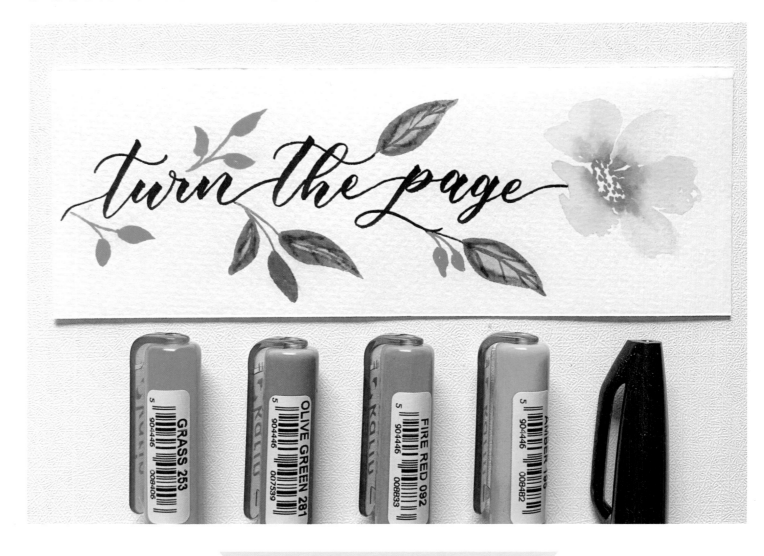

TOOLS & MATERIALS

- Watercolor paper of at least 200 gsm, cut into your desired size of bookmark

- Any water-based brush pens (I'm using Karin Brushmarkers PRO; choose one light and one dark color for the flower, and a variety of greens for the leaves)

- Fine-tipped brush pen (I'm using the Pentel Fude Touch Brush Sign Pen)

- Round paintbrush

- A jar of clean water

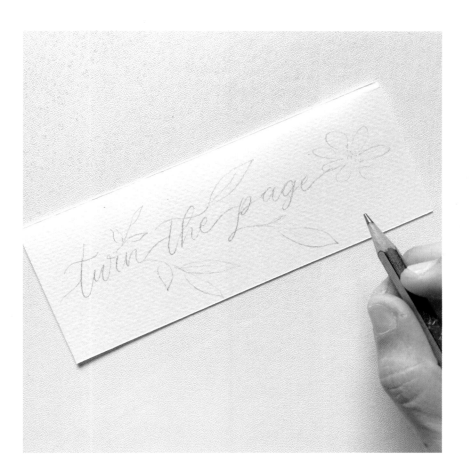

Step 1

With the calligraphy as the stem, draft the quote "turn the page" using bounce lettering (pages 41-47) while extending the exit strokes in each word to make a space between the words.

Draw a simple flower attached to the exit stroke of the last word, and then draw leaves around the calligraphy.

You will notice that I've added a simple flourish to the letter p since I want to add a leaf in that area to balance the composition.

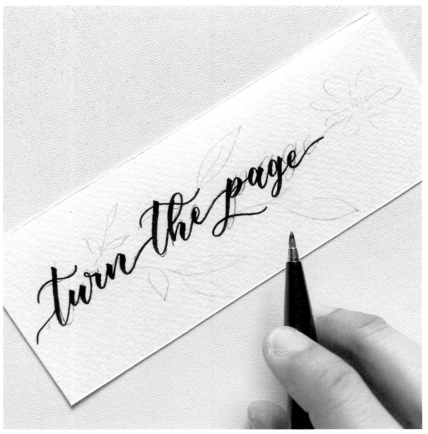

Step 2

Ink the quote using a fine-tipped brush pen. Feel free to adjust the spacing and style of the letters as needed.

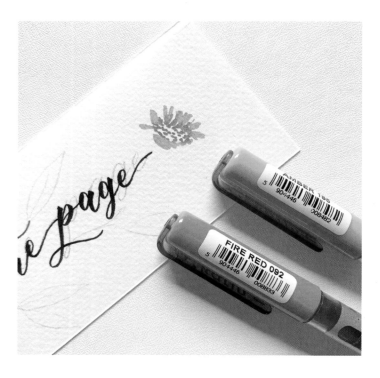

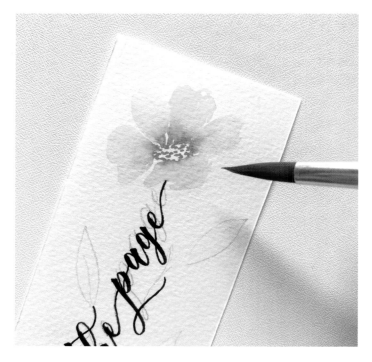

Step 3

Using the darker color you selected, make a flower consisting of dots in an oval shape, with wispy, outward strokes on top of the oval. With the lighter-color brush pen, continue adding wispy strokes around the top part of the dots while drawing a medium-sized crescent below the dots.

Step 4

To paint petals, wet your paintbrush and drag the colors outward from the wispy strokes. The two colors will blend and create a beautiful gradient effect. Don't overthink this step. Press the belly of the brush and wiggle to paint loose brushstrokes. The looser your brushstrokes, the more natural the flower will look. Just remember to leave enough white spaces as you paint the petals to avoid forming a blob.

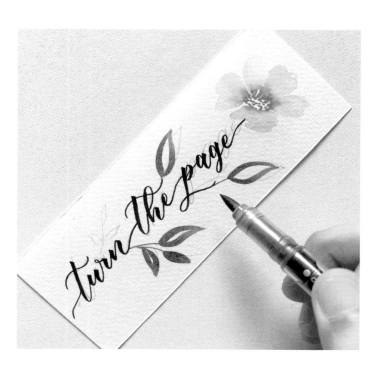

Step 5

Draw big leaves around the calligraphy stem. Press hard on the brush pen to create thick strokes, and then slowly release the pressure to transition to a thin stroke. Leave a white area at the center of the leaf to suggest light.

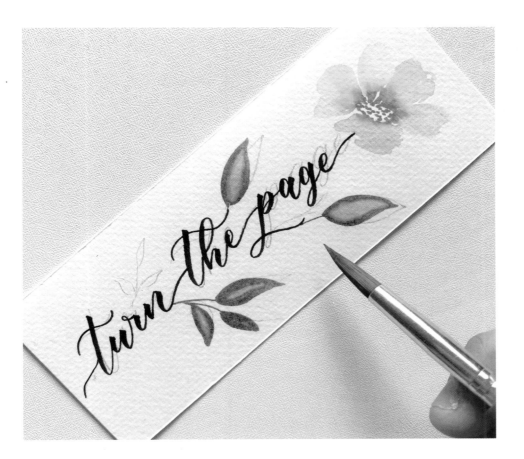

Step 6
With a wet paintbrush, spread the colors of the green brush pen to fill the leaves and make a natural gradient effect.

TIP

Using brush pens to draw leaves is easier, as you already know how to use pressure to achieve varying strokes. Apply light pressure for the stem and heavy pressure to draw teardrop-shaped leaves.

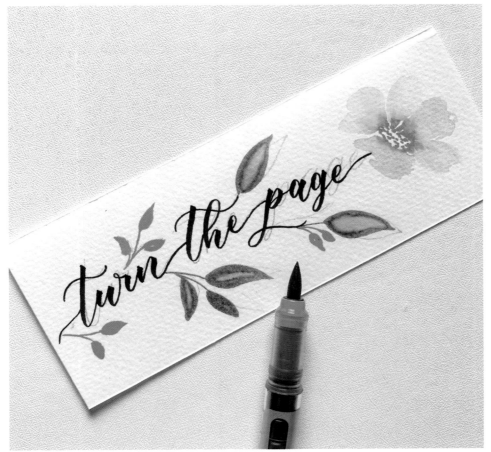

Step 7
Use another shade of green to add smaller leaves to the calligraphy stem. This will fill the empty spaces and complete the floral calligraphy composition.

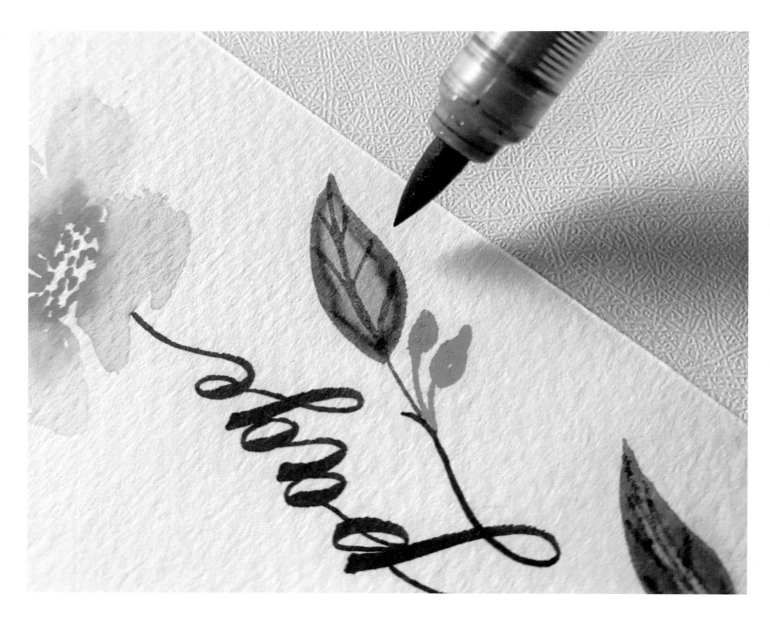

Step 8
Let the big leaves dry. Then you can add details by drawing thin lines that create depth in the leaves.

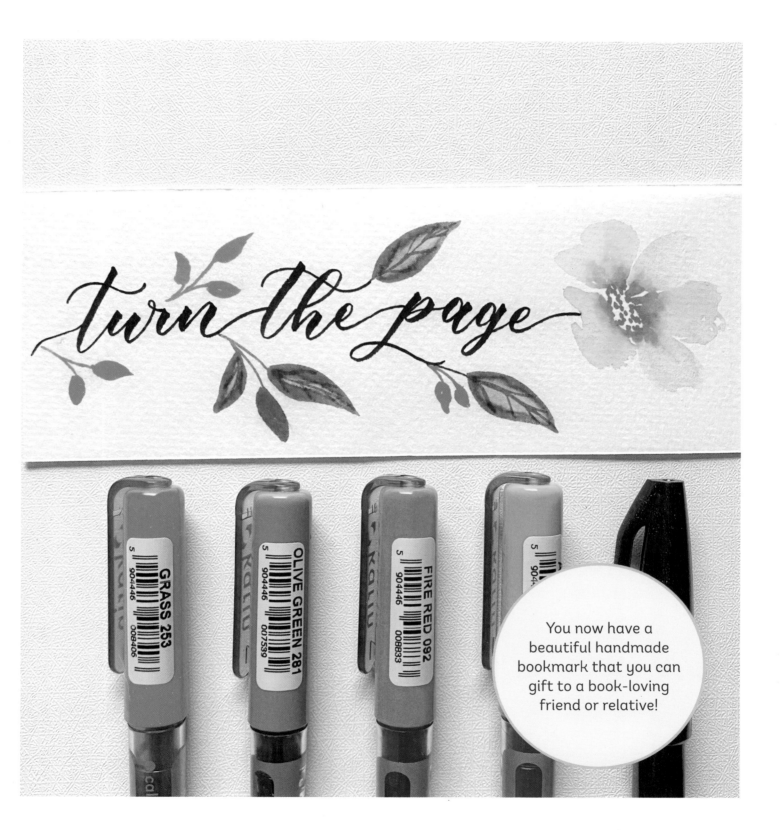

You now have a beautiful handmade bookmark that you can gift to a book-loving friend or relative!

COLORFUL LETTERING WITH FLORALS

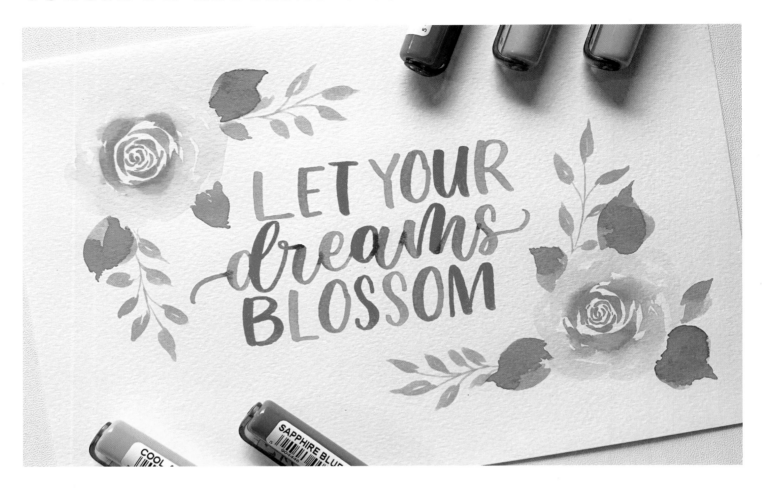

Using brush pens to paint flowers gives you more control as you put pigment on the paper. It also gives you the freedom to keep the florals loose and easy.

Roses are among many watercolor floral artists' favorite flowers to paint. But like most beginners, I found it challenging at first. With constant practice and exploration of different tools, I've discovered a technique for painting a rose using water-based brush pens.

If you're excited to learn this technique and create this colorful project, grab your materials, and let's get started.

TOOLS & MATERIALS

- Watercolor paper of at least 200 gsm

- Set of water-based brush pens in your choice of colors

- Round paintbrush

- A jar of clean water

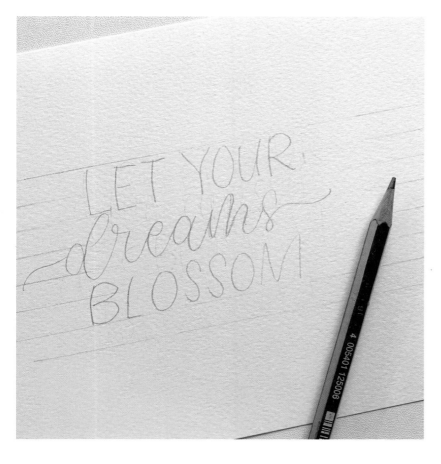

Step 1

Draft the quote: Let your dreams blossom.

I've used a sans serif style for the words "let your" and "blossom" and bounce lettering style for the word "dream," with simple entry and exit flourishes.

When creating a calligraphy composition, remember to fill the negative spaces between each line of words as much as possible.

TIP

If you can't decide which colors to use, you can take inspiration from color palettes on Pinterest.

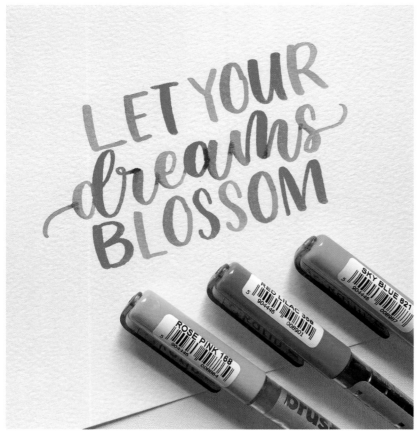

Step 2

Pick three colors from your set of brush pens and alternate them to ink the quote. Wait for the ink to dry, and then erase the pencil marks.

Step 3

Now you can paint the roses around the quote. Start with the center of the upper-left rose by drawing small, overlapping, and thin C-strokes. Make sure to leave enough white space between each stroke to indicate individual petals.

As you move outward, gradually increase the size of the C-strokes until you create the biggest C-stroke for the outer petals.

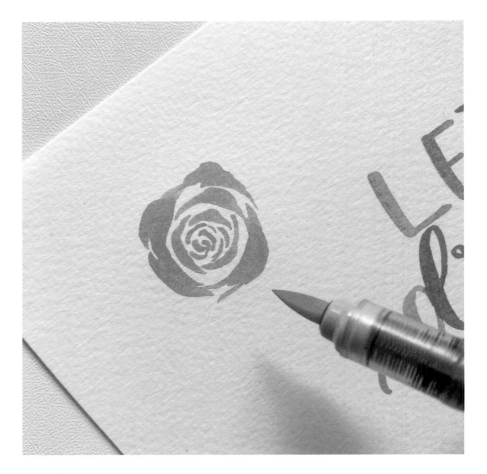

Step 4

Whether you're painting with brush pens or watercolors, the center of the rose must be darker than the softer, lighter outer petals. Wet your paintbrush and drag the pigment from the outer C-strokes to paint the outer petals of the rose.

You don't have to aim for a perfect C-shaped petal; real-life roses have imperfections that make them unique and beautiful. Keep your strokes loose as you paint the petals to make them look more natural.

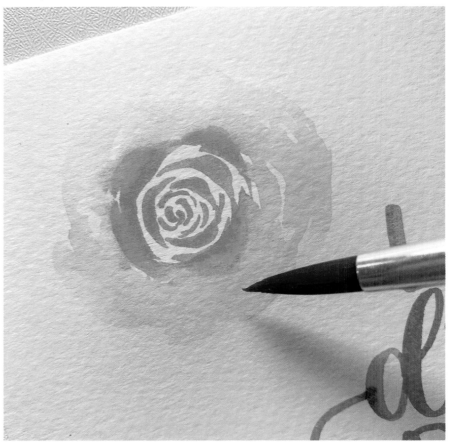

Step 5

Repeat steps 3 and 4 to paint another rose at the lower-right corner of the quote.

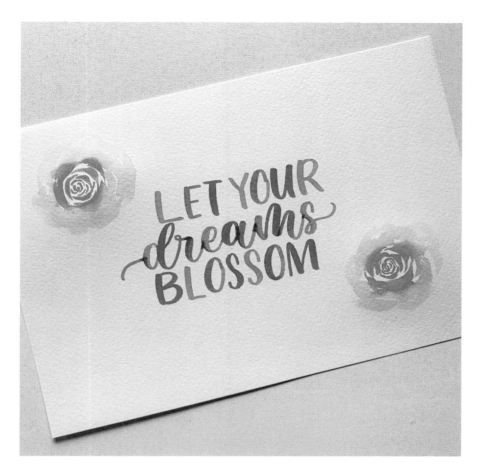

Step 6

The simplest way to add leaves to roses is by drawing a teardrop shape and filling it with colors.

On a nonporous material that you can use as a palette, apply a small amount of ink from a brush pen, and then activate the color with water using your wet paintbrush. To paint big leaves attached to the rose, drag the belly of the paintbrush to create thick strokes. Slowly lift for a pointy tip. Repeat this step for the second rose.

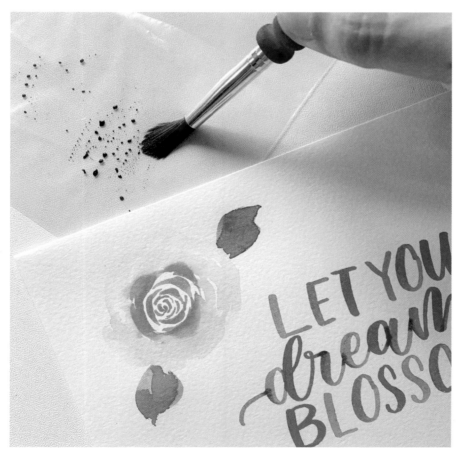

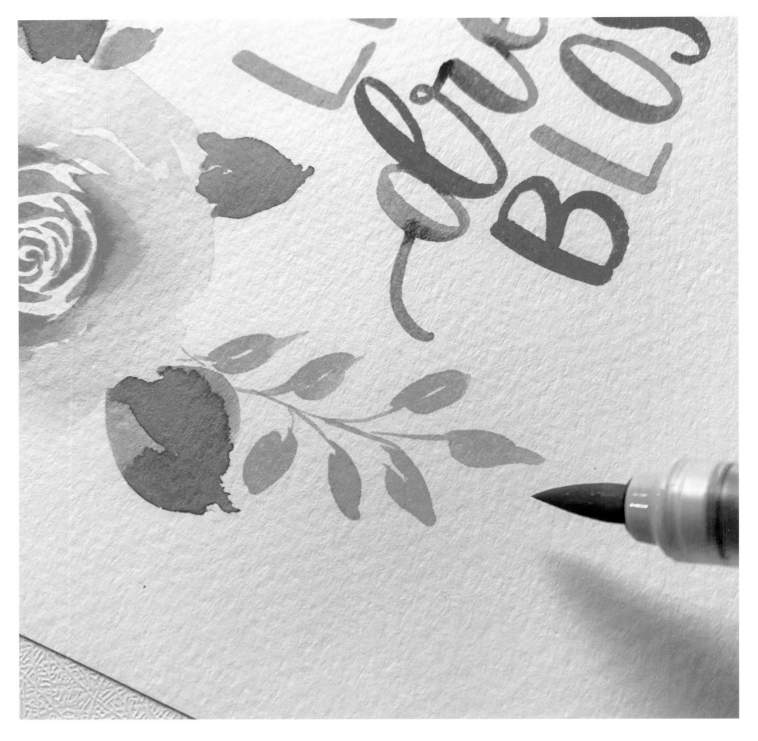

Step 7
Add smaller leaves around the roses to form the border.

Apply a light pressure to draw a thin curve for the stems, and then apply heavy pressure to create thick strokes or oval shapes for the leaves.

Repeat the process on the opposite side of the rose.

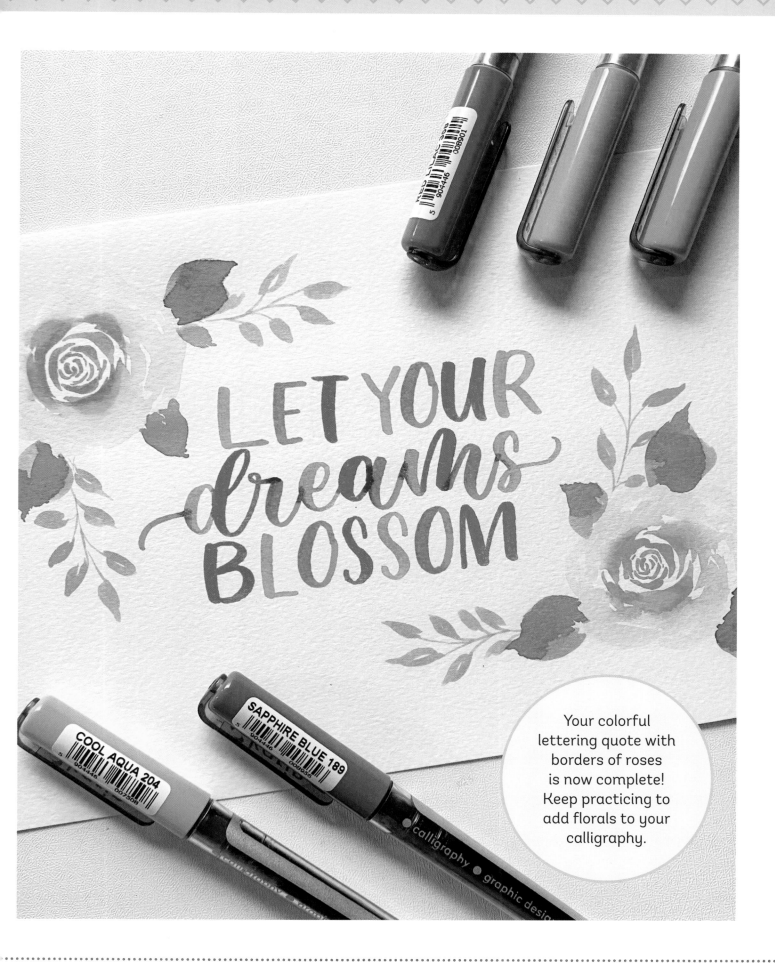

Your colorful lettering quote with borders of roses is now complete! Keep practicing to add florals to your calligraphy.

FLOURISHED QUOTE

Now that you know about the different brush-pen techniques that can enhance a calligraphy artwork, it's time to explore more complicated designs using flourishes.

You've learned how to plan flourishes in a word. What if you want to flourish a quote?

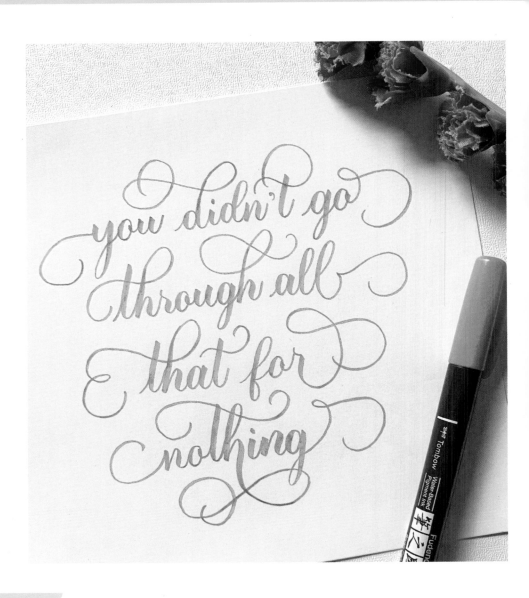

TOOLS & MATERIALS

- Lined paper or blank sheet of paper with guidelines drawn on it

- Pen and pencil

- Fine-tipped brush pen

- Tracing paper or light box

NOTE

To help you understand the process of designing a calligraphy composition with flourishes, I'm using only lowercase letters in this quote. However, if you prefer capital letters at the start of the sentence, feel free to refer to the templates and exemplars for flourishing ideas (page 128).

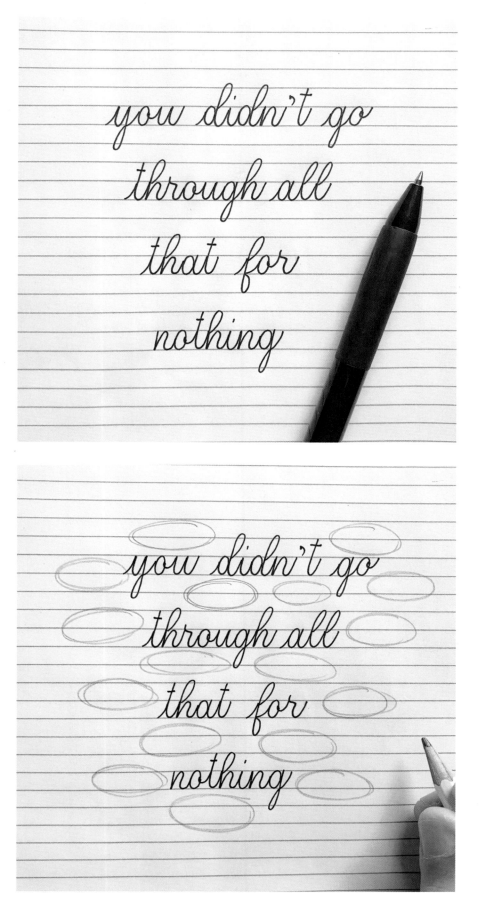

Step 1
Write the quote in calligraphy using a pen. Don't worry about thin and thick strokes, but follow the basic strokes as you write.

Step 2
Look for areas with large spaces, and using a pencil, draw oval shapes. These ovals will indicate where to add flourishes to fill the composition.

Step 3
Draft your first design of flourishes, filling in the oval shapes with embellishments.

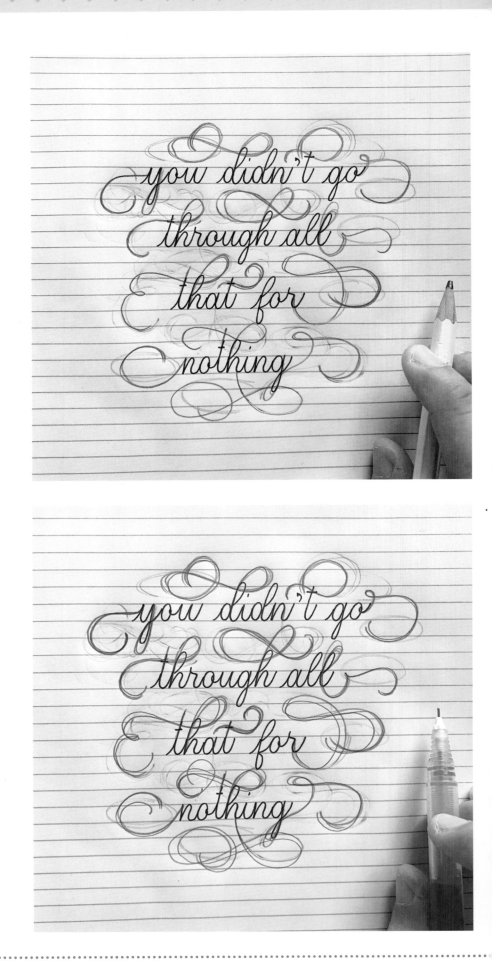

> **TIP**
>
> When designing a calligraphy quote, I like to keep the variety of flourishes simple to avoid overthinking it. Remember that your pencil is your best friend. If you don't like an embellishment, erase it and try a different one. Just keep in mind the overall balance of the composition and the readability of the words.

Step 4
Once you're satisfied with the design, use a colored pen to trace the pencil markings of the flourishes. This will ensure that the flourishes are visible when you transfer the composition to clean paper.

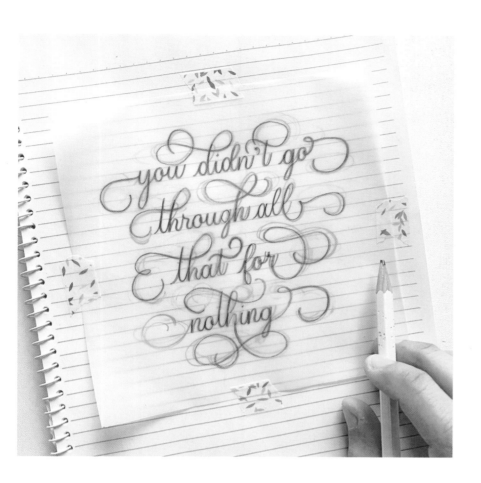

Step 5

If you have a light box, it's easy to transfer the design to another sheet of paper. If you don't have one, tracing paper is a good alternative.

Lay the tracing paper on the design and secure it with washi tape to keep it in place. Trace your design with a pencil.

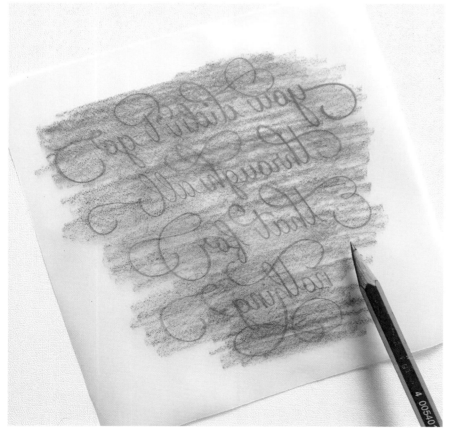

Step 6

Detach the tracing paper and turn over your sketch. Make carbon paper by covering the back of the tracing paper with graphite pencil.

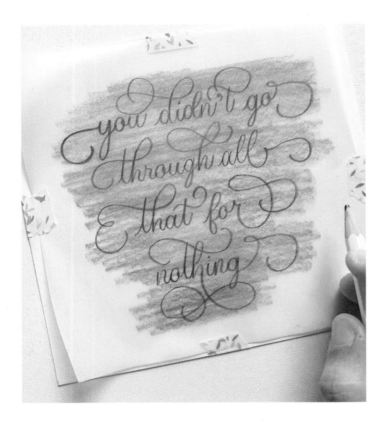

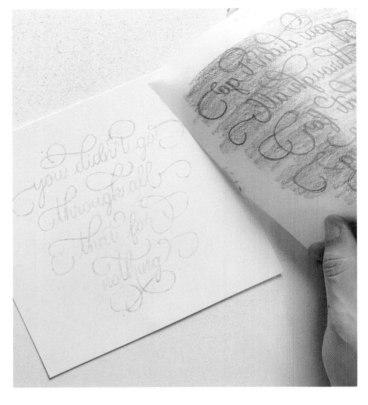

Step 7
Once you've covered the back of the sketch with pencil, turn it over and attach it to the other piece of paper with tape. To transfer the design, trace it again with a pen or pencil.

Step 8
Before detaching the tracing paper, ensure that you've successfully transferred the whole design to the other piece of paper. If everything looks good, gently remove the tracing paper.

Step 9
Finally, ink the design with your brush pen, and erase any pencil marks once the ink is dry.

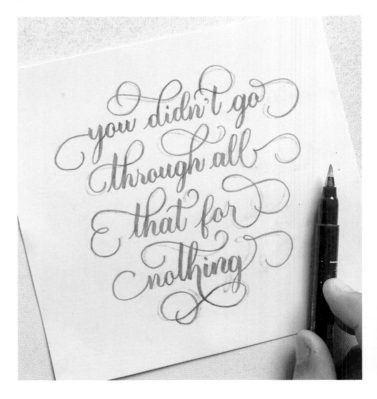

Now that you've learned how to design flourishes in a quote, you can apply the same process to any long sentences or even poems. Keep practicing and try different styles of embellishments until you've come up with a design that you love. The more you practice, the easier designing a composition will become.

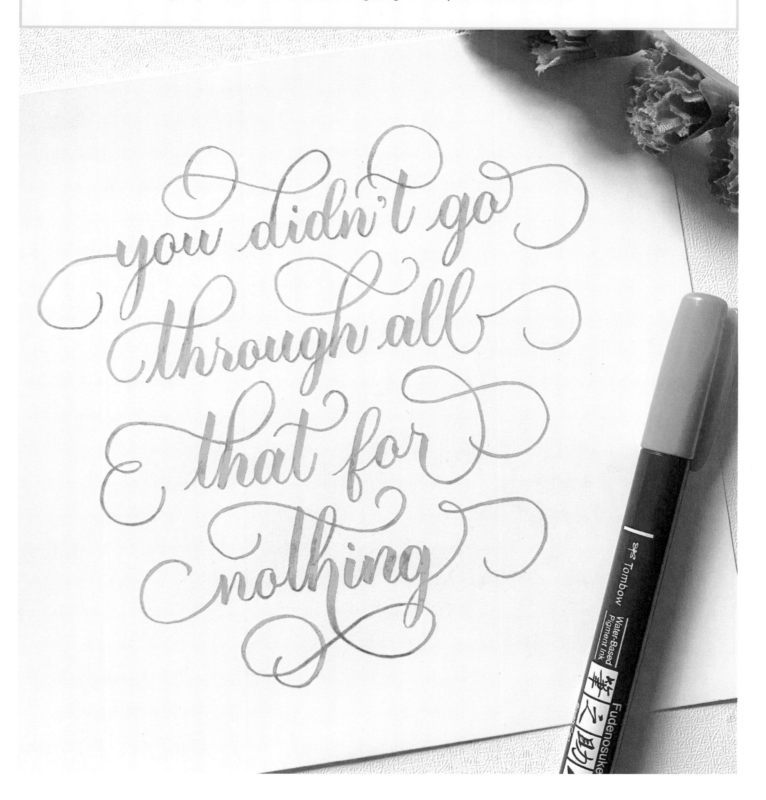

WHIMSICAL FLOURISHES & FLORALS

Mixing bounce lettering and flourishing with florals is one of my favorite ways to express my love for letters. I love how the movement of the strokes in this style looks unrestricted and gives a fanciful vibe, which adds to the feeling of freedom and joy in the viewer.

This next project gives delightful energy to the words, and I feel like dancing when I see them. Whether you are looking for inspiration or exploring something new, this project will show you how to create a modern rendition of flourishing with bounce lettering. I'm excited to share the process with you!

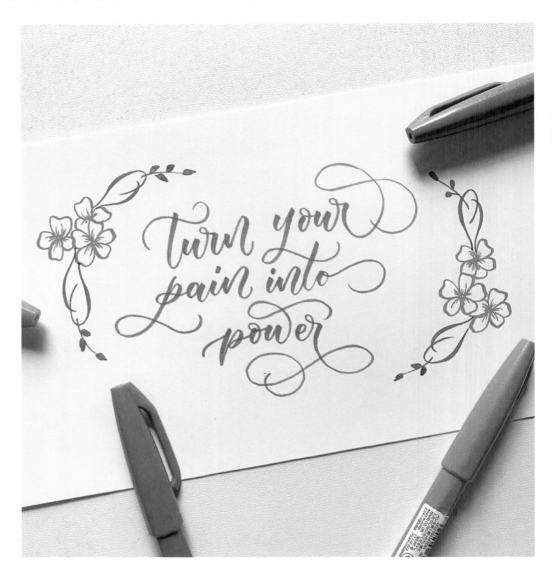

TOOLS & MATERIALS

- Sheet of paper with guidelines

- Pencil

- Fine-tipped brush pens

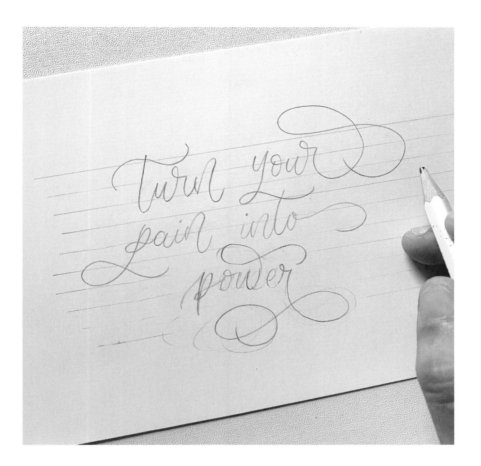

Step 1

Draft the quote "turn your pain into power" using the bounce lettering style, and add simple flourishes. If you struggle with the design of this composition, go to the project on pages 112-117 to learn how to create a flourishing layout for a quote.

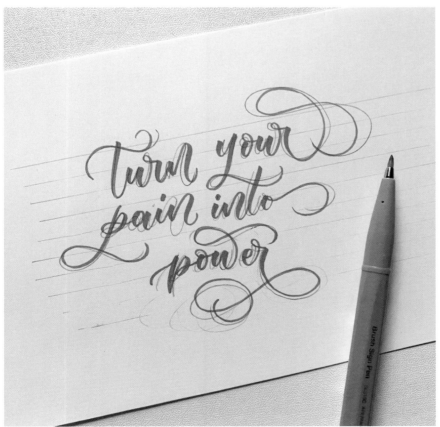

Step 2

Ink the quote with your brush pen, and then erase all the pencil markings once dry.

Step 3

Draw a cluster of a five-petal flowers using a brush pen at the lower-right side of the quote. Add details at the centers of the flowers to create interest.

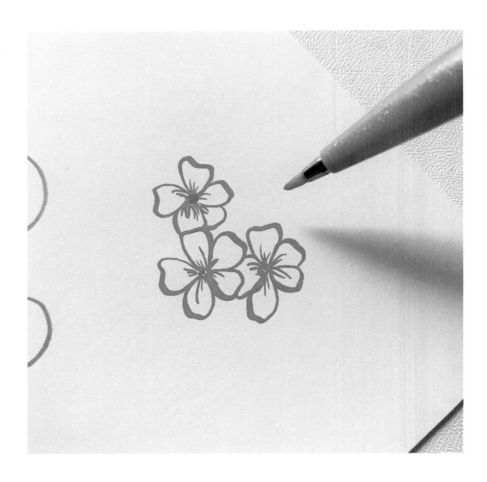

Step 4

Repeat step 3 on the upper-left side of the quote.

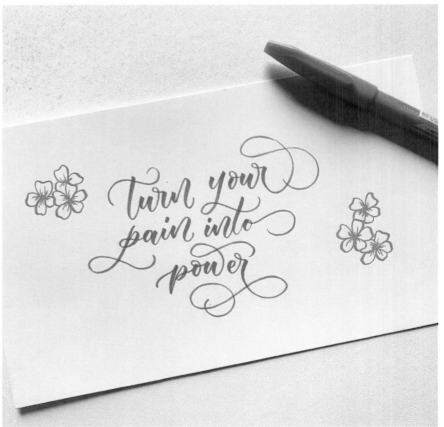

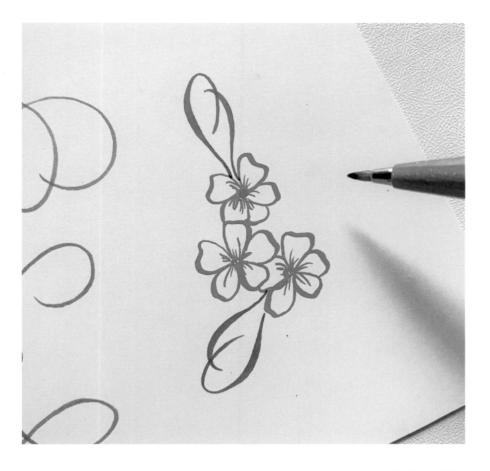

Step 5

Using any color you like, add festive strokes, sort of like a ribbon, on both sides of the clusters of flowers.

To create a festive stroke, start with light pressure and slowly transition to heavy pressure. As you curve to an oval, transition again to light pressure.

Next, draw a shorter version on the opposite side, making the end curvy instead of following an oval shape. Overlap the curves with each other, and now you have a festive flourish!

Make the same strokes on the other side of the artwork.

Step 6

Lastly, add small leaves at the end of each festive flourish. (See page 132 for ideas on flourishing elements.)

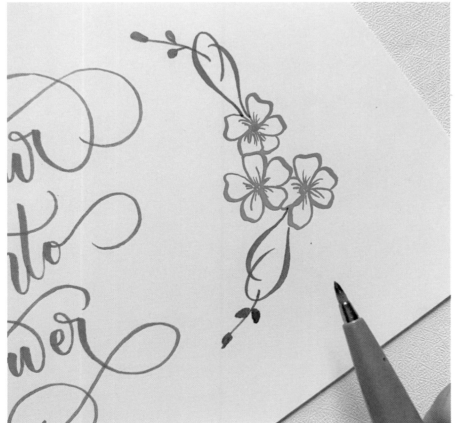

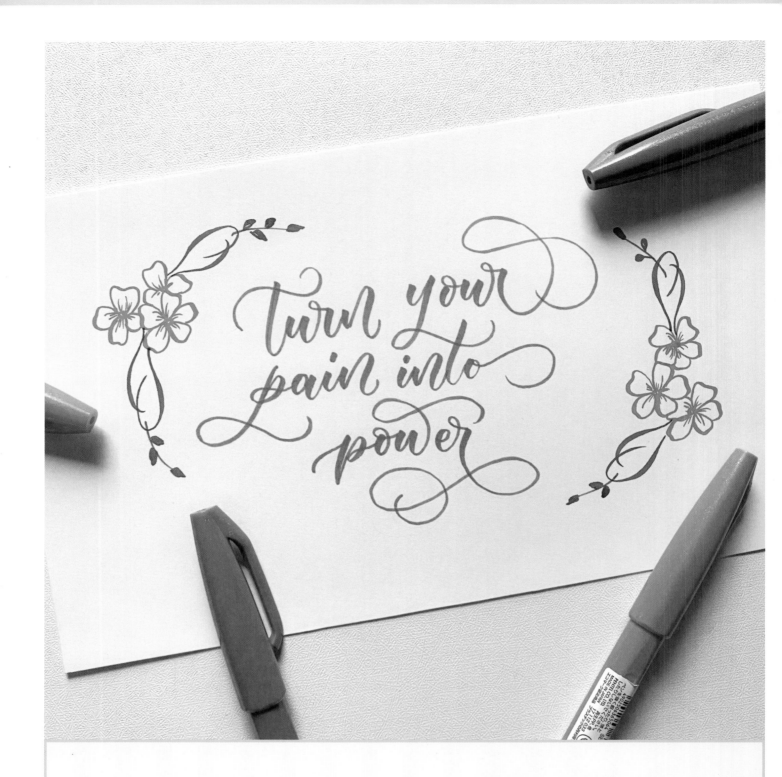

Flourishing is one of the most enjoyable elements of calligraphy, and it's something that can set your work apart. It might take some time before you feel comfortable with flourishes, but have patience and practice, and you will get there. Give it a try, and challenge yourself to discover other styles that you can incorporate into your designs.

CREATIVE PROMPTS & CHALLENGES TO UNLOCK YOUR CREATIVITY

This section offers calligraphy prompts to help you keep the momentum going and hone your newfound skill. You can go through the prompts before practicing if you wish.

Being busy can disrupt your goals, and it's easier to postpone practice time rather than setting aside time for it. But dedicating at least 15 to 30 minutes to sit with your brush pens and have a mindful practice is already enough to improve your calligraphy. Think of it as your daily relaxation after a day of work.

30 Days of Lettering

Challenge yourself to practice one new word each day for 30 days. You can focus on one style for the entire month or mix up the lettering styles if you prefer.

30 Days of Lettering Challenge

Letter each word in any style! Have fun creating.

1. imaginative
2. mindful
3. gifted
4. inspired
5. talented
6. resourceful
7. explorer
8. ideas
9. adventurous
10. practical
11. unique
12. process
13. creative
14. determined
15. passionate

16. fruitful
17. productive
18. willing
19. courageous
20. devoted
21. capable
22. amazing
23. brave
24. artful
25. expressive
26. learning
27. dedicated
28. awakened
29. discover
30. artistic

TIP

You can use your journal to do the prompts or have a dedicated calligraphy notebook in which to compile all your practice attempts. Don't forget to add the date when you practice. It's great to look back later and see your progress.

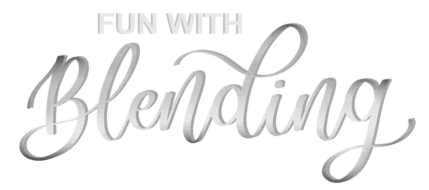

FUN WITH Blending

Week 1
Theme: Summer
Prompt: Sunshine

Week 2
Theme: Winter
Prompt: Frozen

Week 3
Theme: Autumn
Prompt: Mushrooms

Week 4
Theme: Spring
Prompt: Easter

Fun with Blending

Choose a month to dedicate to practicing blending techniques. Start with only two colors, and then progress to three or four color combinations. The prompts will encourage you to work on a specific theme and help you come up with color combinations. The goal is to improve your blending technique skills and get creative with colors.

QUOTES and COMPOSITIONS

Week 1 prompt: Blended lettering on a shape of your choice
Quote: Life is short. Smile while you still have teeth.

Week 2 prompt: Bounce lettering style with feathers
Quote: Let your dreams be your wings.

Week 3 prompt: Combine a brush script of your choice with sans serif
Quote: You were born to be real, not to be perfect.

Week 4 prompt: Flourishing with florals
Quote: "A flower blossoms for its own joy." —Oscar Wilde

Quotes & Compositions

If you're still having a hard time coming up with composition designs for quotes or phrases, this next prompt aims to help you in this area of lettering.

You can do this weekly or for a few consecutive days— whatever works best for you.

Each week or day, have a design idea to create the given quote. For example, week 1 encourages you to try blended lettering on a shape of your choice. You might want to letter the quote in a circle or square and use the blending technique.

Don't limit yourself to the prompts of the week. Explore and think of other designs that spark your creativity!

NEXT STEPS

If you think learning calligraphy will end as soon as you finish this book, let me tell you that it's just the start of your creative adventure. Knowing the basics will build you a strong foundation of skills, but you must commit to putting in the time to continue practicing and developing to become the lettering artist that you want to be.

There are still a lot of lettering styles to learn, and along the way, you will discover your own processes and techniques. With every stroke, letter, or word you practice, you will learn how to deepen your connection with yourself and tune into your thoughts and emotions while tapping into the benefits of mindfulness with the beautiful art of handwriting.

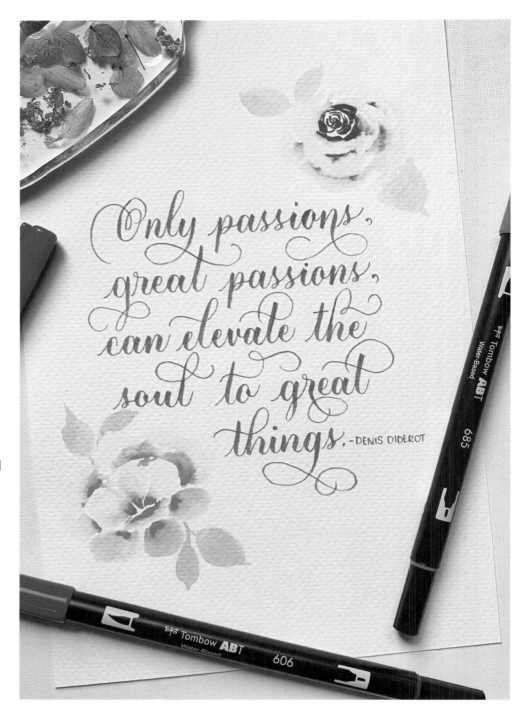

Only passions, great passions, can elevate the soul to great things. —DENIS DIDEROT

Modern calligraphy has been around for years, and its tools and styles are always evolving, but it can have just as much meaning today as it did centuries ago if you're using it as a creative outlet or an artistic form of expression.

I hope that through this book you encountered a world of discovery with calligraphy and that it might lead you to find a passion for it. It is an honor to be a part of your creative adventure. Thank you for reading this book. Have a wonderful calligraphy journey!

TEMPLATES & PRACTICE MATERIALS

Whenever you feel discouraged or frustrated with calligraphy, remind yourself that everyone is different, and it takes time to develop your skills.

In the last pages of this book, I've provided some calligraphy practice sheets that may interest you if you wish to improve your skills.

I also encourage you to consider practicing even when it seems repetitious or you don't have the motivation for it because discipline, persistence, and dedication pay off in the long run.

Days of the Week

Monday Tuesday

Wednesday Thursday

Friday Saturday

Sunday

Flourished Uppercase Letters Exemplar

Most Common Double-Letter Combinations

cc cc cc

dd dd dd

ee ee ee

ff ff ff

gg gg gg

hh hh hh

ll ll ll

mm mm mm

nn nn nn

oo oo oo

pp pp pp

rr rr rr

ss Ss ss

tt tt tt

ww ww ww

yy yy yy

Flourishing Elements

Congratulations

Congralula

Congratulations

Congr

Congratulations

Happy Birthday

H

Happy Birthday

Happy Birthday

Happy New Year

Happy New Year

Happy New year

Merry Christmas

Merry Christmas

Merry Christmas

Welcome Home

Welcome Home

Welcome Home

We cannot become what we want by remaining what we are.

-MAX DEPREE-

Much of spiritual →»→ life is ←«← self-acceptance, maybe all of it. — Jack Kornfield

Be happy in
the moment.
That is enough.
Mother Teresa

Quiet the mind
and the soul
will speak.

What we BELIEVE can significantly affect what we ACHIEVE.